Early Cycladic Sculpture
An Introduction

by
Pat Getz-Preziosi

The J. Paul Getty Museum
Malibu, California

For my family, friends,
and colleagues who have
encouraged me during
twenty years of Cycladic
studies.

Library of Congress
Cataloging in Publication Data

Getz-Preziosi, Pat.
 Early Cycladic sculpture.

 Bibliography: p. 90.

 1. Sculpture, Cycladic. I. J. Paul Getty Museum
II. Title.
NB130.C78G4 1985 733'.3'093915 85-34
ISBN 0-89236-101-8

Cover: Early Spedos variety style
harp player. Malibu, The J. Paul
Getty Museum 85.AA.103. See
also plate IVb, figures 24, 25.

Contents

Foreword

If you rank Brancusi or Jean Arp among the great masters of modern sculpture, then inevitably the Cycladic idols must be closer to your heart than anything from the classical Mediterranean. Since the late nineteenth century, when these marble figures first emerged from a sleep of several millennia to engage the modern aesthetic consciousness, modern sculptors have realized a deep affinity with them. The language of the forms, the taste, and the touch seem to spring from the same source.

For a knowledgeable specialist, however, an abyss of difference underlies this apparent kinship. Modern sculpture is a curved mirror that reflects the hypersophisticated universe of modern man, while Cycladic idols were intended to satisfy the basic needs of a simple society with limited horizons. The self-conscious forms of modern art are like the changeable surface of a soap bubble, always on the verge of exploding. The well-structured beauty of Cycladic idols must have appealed to their people, but such feelings were certainly subordinated to primordial, nonaesthetic purposes. Tensions and contradictions inherent to mankind certainly found some expression in Cycladic art, but even to our eyes, ignorant of their original intentions, the idols incarnate a conscious effort to achieve harmony and order.

One difference is basic. The language of modern artistic forms contains inevitable references to millennia of traditions, influences, and quotations. Modern society cogitates its art, but the art participates, at the very least, in shaping the ways of thinking. The art of Cycladic idols seems, rather, to have fallen from heaven. Of course, the idols conform to a perennial tradition; but the tradition seems to involve only the substance, the fact of making figures.

From very early, if not from his first days, man was creating gods in his own image out of anything that was available, whether carving mammoth ivory that became fossilized or arranging organic material that would perish the next day. Small figures survive from the old Stone Age that perpetuate the omnipresent Mother, the origin of life and source of food, while

her male counterpart remains limited to rare apparitions. This same blueprint seems to have existed in the third millennium B.C. under the blue sky over the Cycladic islands, but how much were the creators of the idols aware of it?

Fishermen and farmers, the people of the Cyclades developed a remarkable skill that endured for many centuries and generations, producing figures from lumps of marble or sometimes from large slabs, to create a highly stylized, often sublime art. The technique can be reconstructed without difficulty, and a few other features are well documented. But one can never emphasize enough that our perception of the idols is inevitably deformed. They appear as white phantoms today, because the rich coloring of the original polychromy has left hardly any traces.

Cycladic idols also present a rare opportunity to understand what the art of a culture is all about because they developed spontaneously from inside a simple community with practically no external interference or influence. Development and changes can be followed, but through several centuries, perhaps through a millennium, Cycladic idols present a uniquely homogeneous creation. Most of the rest of our knowledge about the world of the idols remains guesswork. Patient research by devoted specialists continues to piece together bits of evidence to understand better the original purpose, function, placement, and presentation of the idols as well as their meaning and social background. On the other hand, it is easy to realize that the shapes of the idols are inseparable from the way they were made: the technique and material participate in finding the language of the forms, but they do not create it. The birth of Cycladic sculpture in the third millennium B.C. is a miracle that happens again and again under our eyes, as their art continues to ignite joy in human hearts.

And an absolutely essential feature of any art appears in the Cycladic figures in a very strong way. Art is not just a reflection of the world to which it belongs, it also results from the creative activity of the artist, from the

confrontation of one person with the world, from the fight with and mastering of the specific artistic language. The hands and minds of individuals can be traced in the apparently uniform world of Cycladic idols; the work of individual sculptors becomes palpable through patient, lifelong study and observation. Instead of anonymous marble figures, we can see real people at creative work, communicating in spite of the passage of time and different ways of life. Such identifications of sculptors and their works are successfully made in the large-scale, scholarly work of our author. This booklet not only summarizes her *opus magnum* but also provides a broader introduction to the marvelous world of the Cycladic idols: may a better understanding increase your enjoyment of them.

Jiří Frel

Preface

This book was written at the suggestion of Jiří Frel following a seminar lecture given by the writer at the J. Paul Getty Museum in the spring of 1983. A revised version of that lecture, it also incorporates many elements of a larger study called *Sculptors of the Cyclades: Individual and Tradition in the Third Millennium B.C.*, which will soon be published jointly by the University of Michigan Press and the J. Paul Getty Trust. Illustrated wherever possible with objects from the Getty's collection or with objects in other American museums and private collections, *Early Cycladic Sculpture* is intended to survey the development of Cycladic sculpture and to offer a particular approach to the anonymous artists who worked in the Aegean islands some forty-five hundred years ago.

For graciously allowing me to reproduce objects from their collections and for providing photographs and information, I am most grateful to the following museums, museum authorities, and private owners: Dolly Goulandris (Athens), Adriana Calinescu (Indiana University Art Museum, Bloomington), John Coffey (Bowdoin College Art Museum, Brunswick), J. Gy. Szilágyi (Musée des Beaux-Arts, Budapest), Jane Biers (Museum of Art and Archaeology, University of Missouri, Columbia), Giselle Eberhard (Musée Barbier-Müller, Geneva), Dominique de Menil (Menil Foundation, Houston), Uri Avida (Israel Museum, Jerusalem), Michael Maass and Jürgen Thimme (Badisches Landesmuseum, Karlsruhe), J. Lesley Fitton (British Museum, London), Tina Oldknow (Los Angeles County Museum of Art), Jiří Frel and Marion True (The J. Paul Getty Museum, Malibu), The Guennol Collection (New York), Joan Mertens (Metropolitan Museum of Art, New York), Alexandra Stafford (New York), Paul and Marianne Steiner (New York), Ian Woodner (New York), Michael Vickers and Ann Brown (Ashmolean Museum, Oxford), Sara Campbell (Norton Simon Museum, Pasadena), Frances Follin Jones (The Art Museum, Princeton University), Renée Beller Dreyfus (The Fine Arts Museums of San Francisco), Paula Thurman

(Seattle Art Museum), Saburoh Hasegawa (The National Museum of Western Art, Tokyo), Mr. and Mrs. Isidor Kahane (Zürich), and several private collectors who prefer to remain anonymous. Special thanks are due to Wolfgang Knobloch of the Badisches Landesmuseum and to Andrea Woodner for undertaking the troublesome task of obtaining the weights of the two name-pieces of the Karlsruhe/ Woodner Master. For their help with various aspects of the project, I am especially indebted to the departments of antiquities and publications at the J. Paul Getty Museum. I would also like to thank the Getty Museum seminar participants for their valuable comments and students of Jeremy Rutter at Dartmouth and Karen Foster at Wesleyan for taking part in drawing experiments pertinent to the present study. And last but not least, I gratefully acknowledge a substantial debt to those colleagues whose views I have incorporated into the fabric of my text.

P. G.-P.

Introduction

Over a century ago European travelers began to explore the more than thirty small islands that lie at the center of the Aegean Sea (fig. 1). We know these islands by the historical Greek name of some of them—the Cyclades—so called because they were thought to encircle tiny Delos, sacred birthplace of the gods Artemis and Apollo. A more appropriate name for these rocky summits of submerged mountains might have been "The Marble Isles" or Marmarinai; for many, if not most, of them are excellent sources of the material that was to spark the creative impulses and challenge the energies of sculptors in both prehistoric and historic times.

Nineteenth-century travelers to the Cyclades brought home a number of "curious" marble figurines, or *sigilaria*, as they called them, which had been fortuitously unearthed by farmers' plows. By the 1880's interest in these sculptures, which we now recognize as the products of Early Bronze Age craftsmanship, was sufficiently aroused that information about the culture that produced them was actively sought through excavation.

Since then, recovery of the art and archaeology of the pre-Greek culture that flowered in the Cycladic archipelago has been continuous, both through systematic exploration and through clandestine digging. As a result, several thousand marble objects are now known, providing a rich and varied corpus to study and enjoy.

Cycladic figures or idols, as the most distinctive objects of this early culture are freely called,* have held a strange appeal for nearly five millennia. During the period of their manufacture, roughly 2900–2200 B.C., they were buried with the Cycladic dead, but they were also exported beyond the Cyclades and even imitated nearby on Crete and in Attica where they have also been found in graves. Fragmentary figures, chance finds treasured as magically charged relics, were occasionally reused in later millennia. In modern times Cycladic figures were at first considered primitive, in the pejorative sense of the word, and ugly, and, at best, curiosities from the dim recesses of Greek prehistory. Rediscovered in the twentieth century, largely through the appreciation of

*The term *idol* is accurate if by it no more is meant than "image," as in the ancient Greek *eidolon*.

Figure 1.
The Cyclades and neighboring lands. The dotted line indicates some uncertainty regarding the eastern boundary of the Early Bronze Age culture; possibly Ikaria and Astypalaia ought to be included within its sphere.

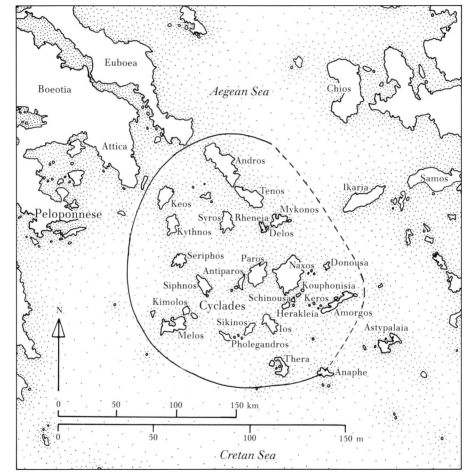

Boeotia

Euboea

Aegean Sea

Chios

Attica

Andros

Samos

Ikaria

Tenos

Peloponnese

Keos

Mykonos

Syros Rheneia

Kythnos

Delos

Seriphos

Paros

Donousa

Antiparos

Naxos

Siphnos

Kouphonisia

N.

Schinousa Keros

Kimolos

Cyclades

Heÿ

Sikinos

Herakleia

Amorgos

Astypalaia

Melos

Ios

Pholegandros

Thera

0 50 100 150 km

Anaphe

0 50 100 150 m

Cretan Sea

8

such artists as Picasso and Brancusi, they have come to be highly esteemed for their compelling combination of gleaming white marble and painstaking workmanship, for the calm force of their essential forms, and for the mystery that surrounds them.

Although the greatest concentration of Cycladic sculpture is housed in the National Archaeological Museum in Athens, examples are scattered in museums and private collections around the world. There are at least two hundred pieces in American collections alone (see the list of major collections on p. 89). The popularity of the figures has increased dramatically during the last two decades, partly because of their perceived affinity with contemporary art styles. The consequences for the serious study of Cycladic art and culture are disturbing, for to satisfy demand for the figures, unauthorized digging has flourished to the extent that for many, if not most, of the sculptures, the precise find-places have been lost along with the circumstances of their discovery. Only a relatively small number of figures has been recovered in systematic excavations of undisturbed sites. The picture we have of Cycladic art has been further clouded by the insinuation of forgeries, primarily during the 1960's.

The fragmentary state of the archaeological record only compounds the very difficult problem of understanding the original meaning and function of these figures as well as other finds from the Early Cycladic period. It is clear that the sculptures had at least a sepulchral purpose, but beyond that, the little we know and the views we now hold are open to the kind of amplification or alteration that only further controlled excavation might provide.

While it is true that the excavation as well as the looting of Early Cycladic sites has been restricted almost exclusively to cemeteries, the few settlements that have been explored have yielded little in the way of marble objects. Perhaps the most important gap in the record at present is the lack of buildings or sites that can definitely be considered sanctuaries, although there is one tantalizing possibility which will be discussed later. For the

moment, it seems advisable to accept the theory that all the figures were apparently destined for use in graves.

Even though a number of graveyards have been properly excavated, so far there is not a single instance in which a Cycladic figure has been found with a skeleton whose sex has been recorded. It is, therefore, unclear whether figures were buried with both men and women, but it seems at least fairly certain that they were not placed in the graves of children. Moreover, while some cemeteries are noticeably richer in marble goods than others, even in these not every burial was so endowed. Marble objects, figures as well as vessels, accompanied only a privileged few to their graves. It is thought that the majority of the islanders made do with less costly wooden figures (all traces of which would have vanished by now), just as they had to be content with vessels fashioned from clay.

At present, there is not even enough archaeological evidence to state with assurance whether these figures were normally accorded respect at the time of their interment with the dead who were placed in cramped, unprepossessing, boxlike graves. Clear information of this sort could provide clues to part of the mystery surrounding the identity and function of these images and to the attitudes of the living toward them.

Perhaps the most intriguing question of all concerns meaning: why did people acquire these idols? Because the majority are female, with a few either pregnant or showing signs of postpartum wrinkles, the evidence points in the direction of fertility, at least for the female figures. Glancing for a moment at the double-figure image of plate III, it might be viewed as essentially similar to the traditional single female figure while being even more powerfully or blatantly symbolic of fertility. By depicting the standard figure type as both pregnant and with a child, the sculptor was able to intensify the idea of fecundity and and the renewal of life. This should provide an important clue to what may have been the essential meaning of these prehistoric marble figures.

For the time being, one may think of these sculptures as the personal

possessions of the dead rather than as gifts made to them at the time of their funerals. They should perhaps be viewed as icons of a protective being acquired by a person, kept during his or her lifetime and perhaps displayed in the home, but whose ultimate and primary purpose was to serve in the grave as potent symbols of eternal renewal and hope and as comforting reminders that life would persist in the beyond. Reaffirmation of the vitality of life and the senses, moreover, may have been the symbolic purpose of the occasional male figure—music maker, wine offerer, hunter-warrior. In the absence of written records, one will never be able to achieve a complete understanding of such intangible matters as burial ritual or the full meaning of the images. Such are the limits of archaeology.

A great deal can be learned, nevertheless, about Early Cycladic sculpture from a primarily visual approach which focuses less on the intriguing but, in the present state of knowledge, difficult questions concerning why figures were carved, for whom they were intended, or even precisely when they were made, and more on the questions of how they were designed and by whom. What follows, then, is a survey of the typological development of Early Cycladic sculpture. In addition, it is the intention here to show that it is possible to isolate the works of individual sculptors and to speculate about these individuals' growth as artists working within the strict conventions of a sophisticated craft tradition.

Plate 1. Four Early Cycladic marble vases.

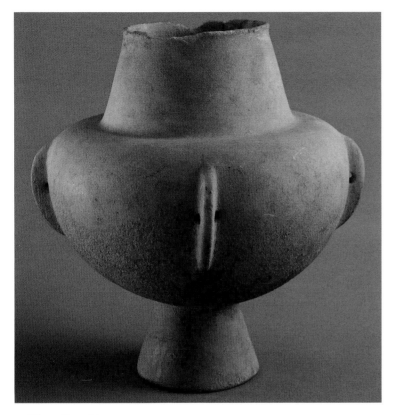

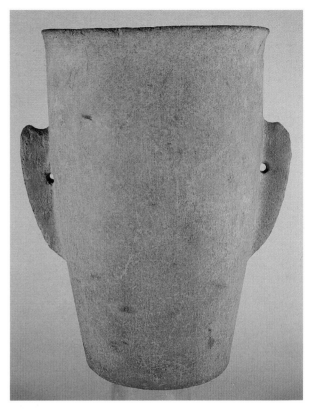

a. *The collared jar or kandila (lamp) was, along with the simple bowl, the most common marble object produced in the EC I phase. Several hundred of these vessels are known. Lidless, they were carried suspended from cords and were probably designed to hold liquids, although one was found containing shells. This is an unusually large and fine example of the type. Pasadena, Norton Simon Collection N.78.10.1.S.A. H. 27 cm.*

b. *The beaker is another of a limited range of marble forms of the EC I phase. Lidless like the collared jar, it was also designed for suspension and was probably intended as a container for liquids, but it occurs much less frequently. In rare cases a female torso is represented on one side of the vessel (with the suspension lugs doubling as upper arms), reinforcing the notion that the vessel was symbolically interchangeable with the plastically sculpted female image. This is one of the largest and finest examples of the type.*

New York, Woodner Family Collection. H. 27 cm.

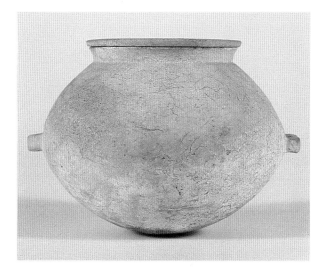

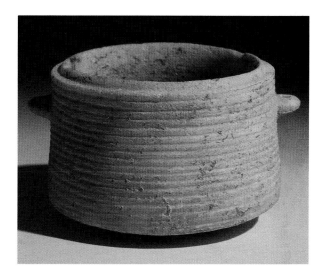

c. The EC II phase saw a dramatic increase in vessel forms which paralleled developments in figurative sculpture. One of the popular vase types of the period was the small, spherical pyxis with lid. Perforations that in the EC I phase had been made horizontally through vertically oriented lugs were now made vertically through horizontal or tubular lugs which, in this fine example, were carved in joined pairs on each side. In this case, too, the lid was provided with perforations that were aligned with similar holes in the rim of the vessel so that the two parts could be tightly secured. New York, Frederick Stafford Collection. H. 9.5 cm.

d. EC II cylindrical pyxides normally carried incised decoration. While curvilinear designs (spirals, circles) are confined almost exclusively to vessels carved in softer and less friable soapstone, marble containers were regularly ornamented with rectilinear encircling grooves reminiscent of the postpartum wrinkles seen on a number of figures (e.g., fig. 6)—perhaps another indication of the female symbolism of the vessel. This beautifully carved example, which shows traces of red paint on its interior, is at present unique among marble vessels for the single engraved spiral which covers its underside. New York, Paul and Marianne Steiner Collection. H. 9 cm (lid missing).

Plate II. Two female figures in the J. Paul Getty Museum.

a. *Plastiras type. EC I. Simpler than most examples of its type, this modest work is unusual in that it lacks any definition of the forearms. The mending hole in the right thigh was a remedy for damage incurred perhaps when the sculptor was in the process of separating the legs. If this was the case, he may have thought it best not to continue separating them as far as the crotch. A break across the left thigh probably occurred at a much later time. Malibu, The J. Paul Getty Museum 71.AA.128. H. 14.2 cm. See also figure 13d.*

b. *Precanonical type. EC I/II. Although one can see in this figure a tentative folding of the arms fore-shadowing the classic idol of the EC II phase, it is still very much related to the earlier Plastiras type in its long neck, modeled limbs, and feet with arched soles (fig. 13e) very similar to those of the piece illustrated in plate IIa (fig. 13d). Although the almond-shaped eyes and the indication of the brows are related to those painted on later figures, their sculptural rendering connects them to the*

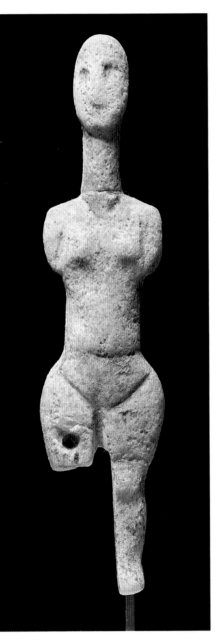

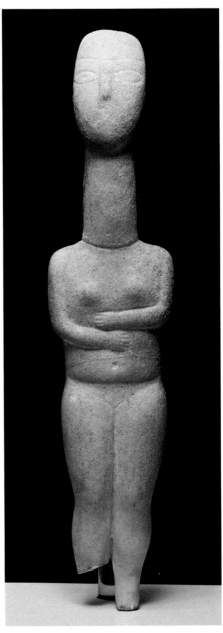

earlier tradition, as does the bored navel (cf. fig. 15c). Note how the legs were carved separately for only a short distance. The modeling and attempted naturalism of the forearms and hands reflect a short-lived approach taken by some sculptors of precanonical figures (cf. pl. III). The figure was acquired by the J. Paul Getty Museum in two parts: the headless idol came to the museum in 1972, having been obtained many years earlier in the Paris flea market. In 1977, during a visit to a European antiq-uities dealer, J. Frel iden-tified the head/neck as belonging to the same work. Malibu, The J. Paul Getty Museum 72.AA.156/ 77.AA.24. H. 28.2 cm.

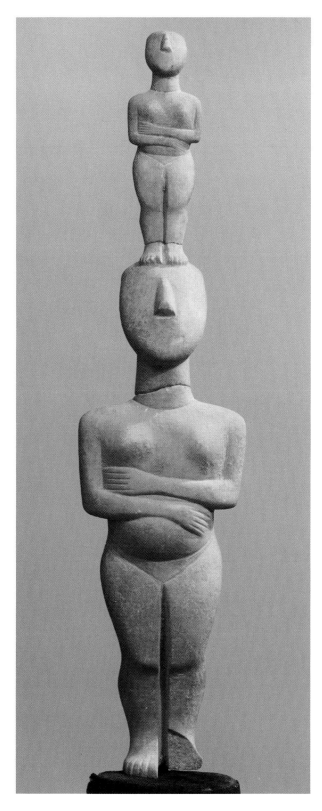

Plate III. Female two-figure composition.

Precanonical type. EC I/II. Probably the earliest and also the largest of the three well-preserved and unquestionably genuine examples of the type known to the writer, the piece is interesting for a number of reasons. The two figures were deliberately made to be nearly exact replicas of each other, with one difference: the larger is clearly represented as pregnant while the smaller has almost no midsection at all. This is probably of some significance for an understanding of the precise meaning of such compositions, which continues to be elusive but which must have suggested fertility. Such works were exceedingly difficult to carve to completion without sustaining fractures, especially at the ankles of the small image, and consequently were rarely attempted.

In their proportions and with their fully folded arms, the two figures are close typologically to the Spedos variety, but the naturalistic rendering of the forearms and hands, in addition to the well-defined knees and slightly arched feet held parallel to the ground, are indica-tions that the work belongs to the late transitional stage. Typologically, at least, it appears somewhat later than the figure illustrated in plate IIb. Private collection. H. 46 cm.

15

Plate IV. Two harp players.

a. *Precanonical style. EC I/II. The earliest known example of a rarely attempted type requiring enormous patience and skill, the figure is seated on a chair with an elaborate backrest, based, like the harp, on wooden models. He is represented in the act of plucking the strings of his instrument with his thumbs. Note the light caplike area at the top and back of the head which was once painted. New York, The Metropolitan Museum of Art, Rogers Fund, 47.100.1. H. 29.5 cm.*

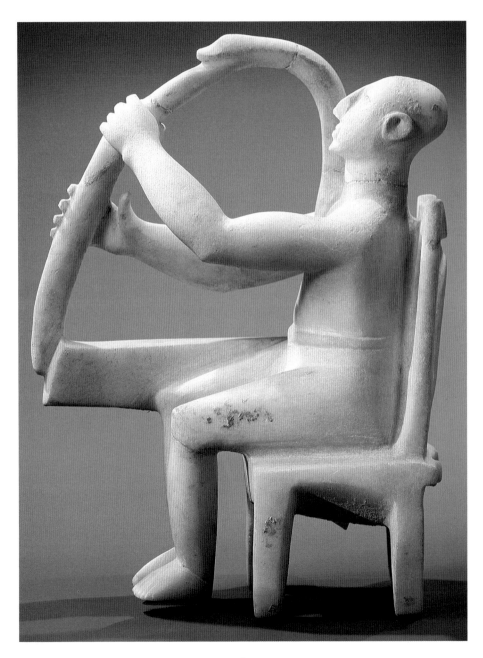

16

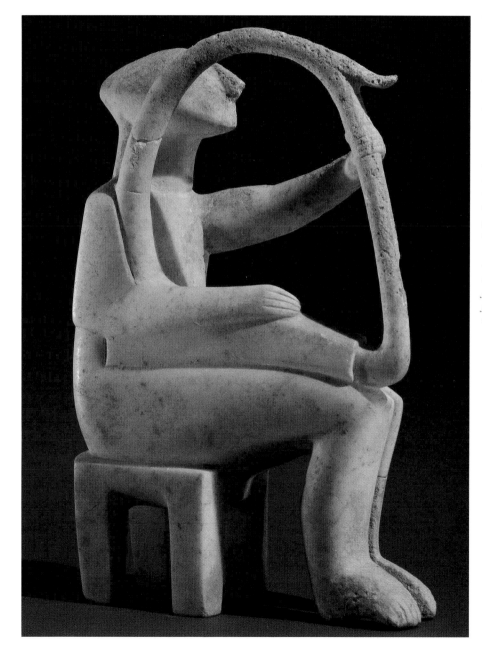

b. *Early Spedos variety style. EC II. This is the largest and, along with the Metropolitan Museum's example, the best preserved of the nine surviving harpers of unquestionable authenticity known to the writer. The figure is represented holding his instrument at rest. Note the subtle rendering of the right arm and cupped hand. Paint ghosts for hair and eyes are discernible. Malibu, The J. Paul Getty Museum 85.AA.103. H. 35.8 cm. Said to come from Amorgos. See also figures 24 and 25 and cover.*

Plate v. Heads of four figures.

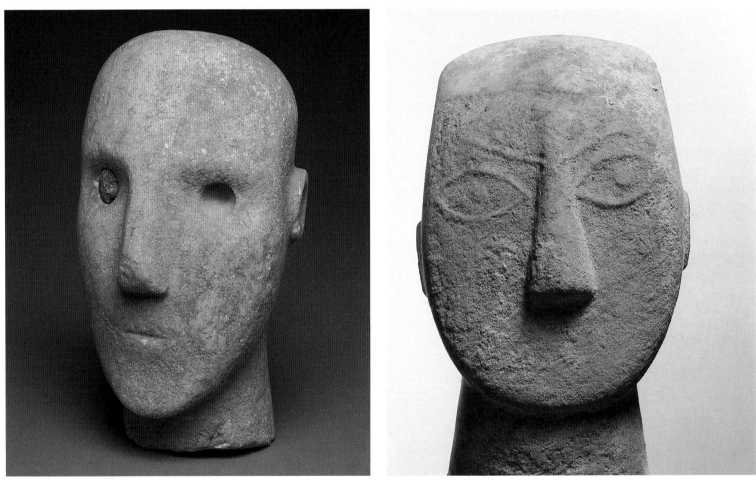

a. *Plastiras type. A work of the Athens Museum Master. EC I. One of three works ascribed to this sculptor, each of which has one eye inlay preserved. Geneva, Barbier-Müller Museum BMG 209-59. Pres. H. 13.6 cm.*

b. *Detail of figure 56 showing paint ghosts for eyes, brows, and forehead hair.*

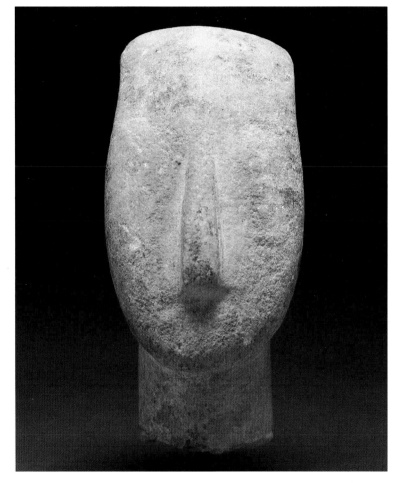

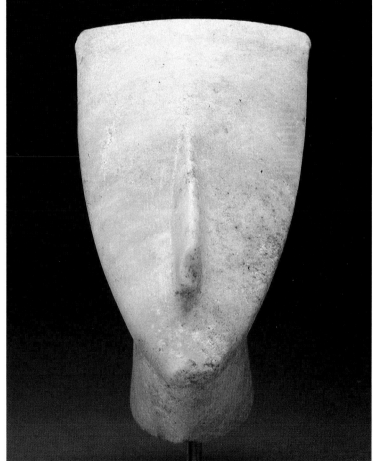

c. *Spedos variety. EC II.
A typical head on which
faint paint ghosts are
visible for the eyes and
forehead hair. Malibu,
The J. Paul Getty
Museum 71.AA.125.
Pres. H. 8.9 cm.*

d. *Dokathismata variety.
EC II. In contrast to the
rather conservative form
of the Spedos variety head
(c), that of the Dokathis-
mata variety is usually
rather extreme and
mannered. Note the broad
crown and pointed chin.
The head is carved in a* *rather unusual striated
marble. Malibu, The J.
Paul Getty Museum
71.AA.126. Pres. H. 8.6 cm.*

Plate VI. Painted details.

a. *Detail of figure 41 showing painting on the face and neck. See also figure 42.*

b. *Detail of figure 41 showing painting of the hands. Note also the modeling of the breasts and arms.*

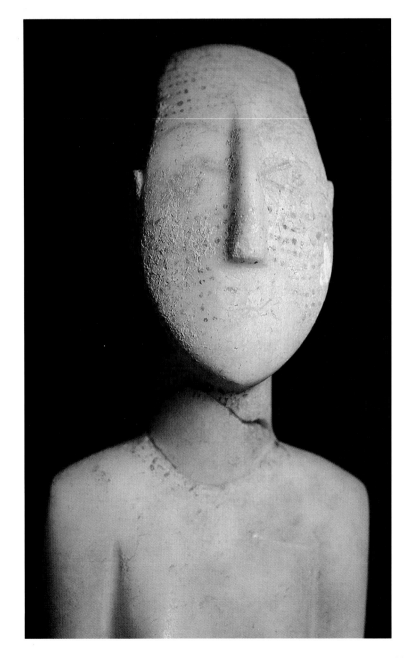

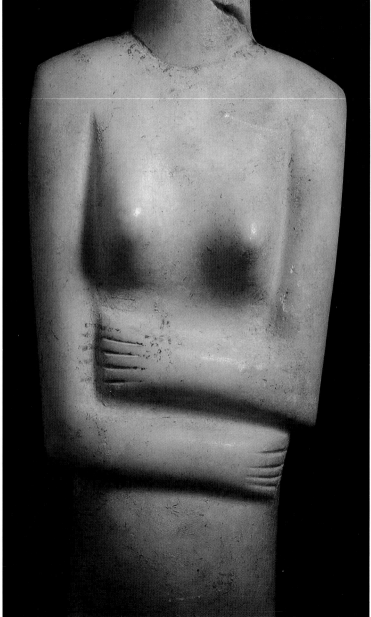

c. *Detail of figure 77
showing painting on the
face and in the neck
groove.*

d. *Detail of figure 77
showing the painted ear
and neck grooves.*

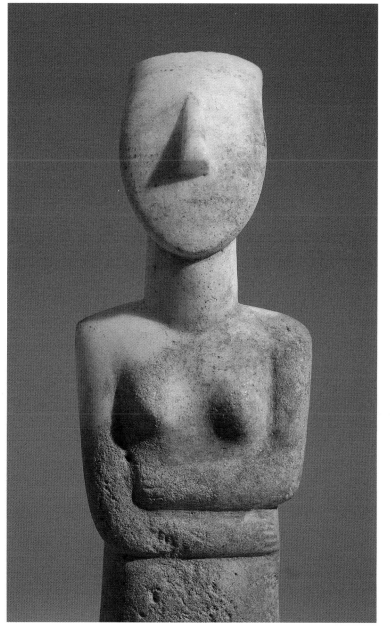

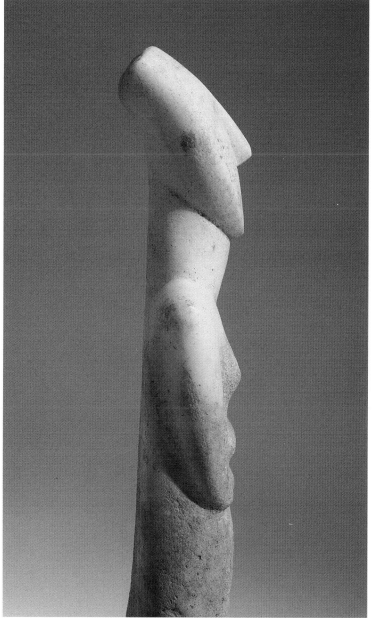

The Stone Vases

Early Cycladic sculptors probably spent most of the time they devoted to their craft fashioning stone vases (pl. 1). In all phases of Early Cycladic culture, these cups, bowls, goblets, jars, beakers, boxes, palettes, trays, and animal-shaped containers were far more numerous as a group than the figures. Like the figures, they were evidently acquired to be used later in the grave. On occasion, they have been found in graves that also yielded idols, although some of the spherical and cylindrical types can be viewed as symbols of the womb and, as such, may as a rule have been regarded as appropriate substitutes for the predominantly female images. A few examples of the rectangular forms, on the other hand, appear to have been made to hold figures (fig. 2).

Even though this book is restricted to a discussion of figurative works, in a very real sense the term "Cycladic sculpture" ought to embrace both the so-called idols and these often very beautiful, though strangely neglected, vessels of marble or, in rare cases, of softer stones.

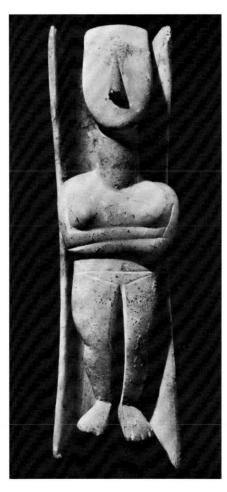

Figure 2. Female folded-arm figure (Early Spedos variety) with trough-shaped palette. EC II. *Reputedly found together as shown, the two objects fit each other well; they are carved in the same marble and are similarly preserved. Although no examples have been found in systematic excavations, the combination seems a plausible one, given the reclining posture of the folded-arm figures. The rather carelessly crafted idol is of interest chiefly for the highly unusual reversal of the arms which, except in the very late examples, are almost without exception held in a right-below-left arrangement. Note, too, the asymmetry of the shoulders and feet. The latter match the unequal length of the pointed ends of the palette/cradle. Jerusalem, Israel Museum 74.61.208a, b. H. (figure) 19.5 cm. L. (palette) 20.5 cm.*

The Figurative Sculpture

The vast majority of the figures are made of sparkling white marble; works in gray, banded, or mottled marbles or in other materials such as pumice, shell, and lead are rare exceptions. The images vary in size from miniatures measuring less than 10 cm (4 in.) (fig. 3) to nearly life-size (fig. 4), although most do not exceed 30 cm (1 ft.).

In terms of naturalism, the sculptures range from simple modifications of stones shaped and polished by the sea to highly developed renderings of the human form with subtle variations of plane and contour. In many examples, no primary sexual characteristics are indicated, but unless these figures are depicted in a specifically male role (pl. ivb), they are usually assumed to represent females. The female form, sometimes shown as pregnant (figs. 5, 74) or with postpartum skin folds (figs. 6, 7), dominates throughout the period. Male figures account for only about

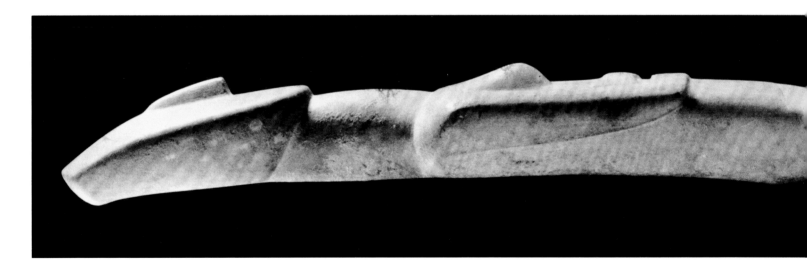

Figure 3. Female folded-arm figure. Late Spedos/Dokathismata variety. EC II.
This is one of the smallest complete figures of the folded-arm type known. Diminutive images such as this one tend to be rather crude in their execution and are probably for the most part examples of their sculptors' early work. Note the disparity in the width of the legs caused by the misalignment of the leg cleft. Athens, Goulandris Collection 350. H. 9.5 cm.

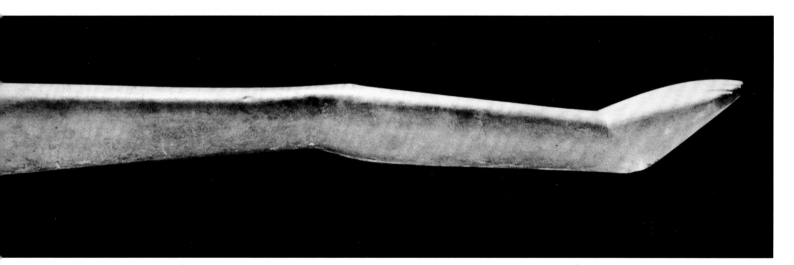

Figure 4. Female folded-arm figure. Early Spedos variety. EC II.
The second largest completely preserved figure now known to the writer (the largest work, in Athens, measures 148 cm), the piece is remarkable for the superb state of its surface. Breaks at the neck and legs may have been made intentionally in order to fit the figure into a grave that otherwise would have been too short for it. Although somewhat ungainly in its proportions, the work was carved by a highly skilled sculptor. Belgian private collection. H. 132 cm. Said to be from Amorgos. See also figure 34.

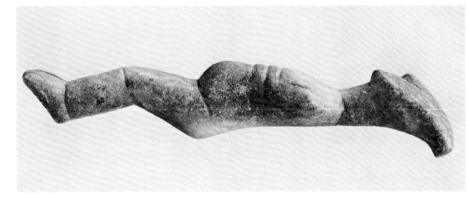

Figure 5. Female folded-arm figure. Late Spedos variety. EC II.
Unlike most figures that are represented in a pregnant condition (e.g., figs. 70, 72, 74), this example shows a rather advanced stage. Athens, Goulandris Collection 309. H. 15.7 cm. Said to be from Naxos.

five percent of the known production (pl. IV, figs. 19, 23–27, 35, 36).

A characteristic feature of Cycladic sculpture throughout its development, from its earliest beginnings in the Neolithic Age, is the simultaneous manufacture of both a simplified flattened version of the female form and a more fully elaborated one (fig. 11). Although the popularity of each type varies in a given period, it appears now that at least some examples of both types appear in every period, except perhaps in the first phase of the transitional one when there seems to have been a blending of the two types. That one Cycladic islander might ac-quire both schematic and representational idols is suggested by their occasional presence in a single grave (fig. 7). Many sculptors probably carved both types, but the schematic figurine was doubtless the less expensive to make, since it was normally small and could be fashioned from a flat beach pebble, thus requiring much less work; as many as fourteen of them have been found together in one grave.

The forms that Cycladic sculptures took sometime after the beginning of the Early Bronze Age (Early Cycladic I) appear to be directly related to the figures carved in much smaller num-

Figure 6. Female figure. Louros type. EC I/II. *Rather crude and clumsy, this figure is atypical because it incorporates features reminiscent of the Plastiras type, namely, plastically treated mouth and forearms. Note, however, that the outline* contour of the arms reflects the stumplike projections characteristic of the Louros type (e.g., fig. 14). The sculptor, perhaps not a specialist, appears to have been confused since he carved the breasts below the arms. The figure shows engraved lines across the front to indicate post-partum wrinkles or possibly bindings. A convention more decorative and easier to render than the rounded belly normally associated with pregnancy and childbirth, such markings are found almost exclusively on the flatter figure types, although in one or two rare cases they occur in combination with a slightly swollen abdomen. Princeton, The Art Museum, Princeton University 934. H. 25 cm.

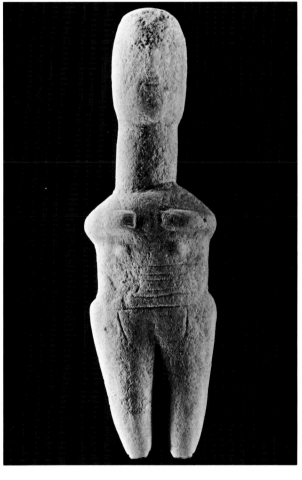

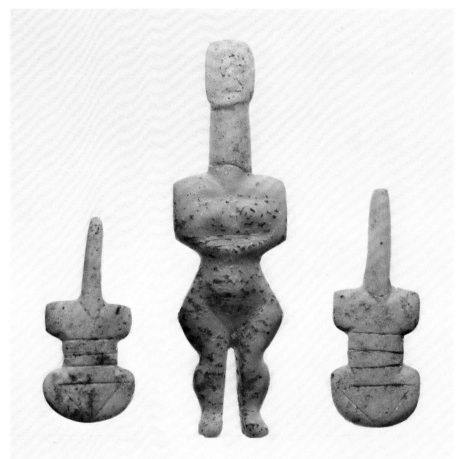

Figure 7. Female figures. Violin type (*a, c*). Plastiras type (*b*). EC I. *This group of modest works is reputed to have been found together, as the character of the marble, state of preservation, and workmanship seem to confirm. That they were* also carved by the same sculptor is strongly suggested by similarities in the outline contours, particularly in the area of the shoulders and upper arms. (A small beaker of the type illustrated in plate Ib was also allegedly part of the group.) The recovery of schematic and representational figures in the same grave is attested for both the EC I and EC II phases. Columbia, Museum of Art and Archaeology, University of Missouri 64.67.1–3. H. 7.6–14.1 cm.

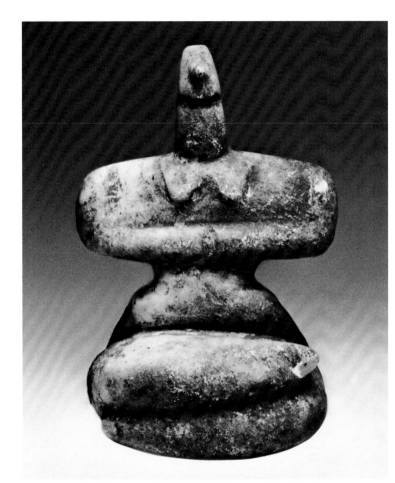

bers during the Neolithic Age (figs. 8, 9). For their more representational figures, Cycladic sculptors used the standing posture and an arrangement of the arms in which the hands meet over the abdomen (fig. 10), both inherited from the earlier tradition. Exaggerated corpulence, the hallmark of the Stone Age figure, was reduced to a two-dimensional, strongly frontal scheme. These images are also broad across the hips, but, unlike their predecessors, they have straight, narrow profiles, as is illustrated by a comparison between the profiles of two Late Neolithic figures and three Early Cycladic ones (fig. 13).

It is doubtful that this fundamental alteration in the sculptors' approach to the female form reflects a change in religious outlook or in aesthetic preference. Most probably the new trend was initiated by the sculptors themselves in an effort to speed up the carving process. It is possible, too, that there was some influence from wooden figures which may have filled the long gap in time between the last of the Neolithic marble figures and

Figure 8. Female figure. Sitting type. Late Neolithic.
One of two basic Late Neolithic postural types, the steatopygous sitting figure with folded legs was the full-blown version of and the original model for the flat, schematic violin type figures (e.g., fig. 7a, c) already produced in limited numbers in Late Neolithic times. Note the exaggerated breadth of the upper torso necessitated by the position of the forearms. New York, private collection. H. 13.1 cm. Said to be part of a grave group from Attica.

Figure 9. Female figure. Standing type. Late Neolithic.

The standing counterpart of the steatopygous sitting figure, this was the prototype for the earliest representational figures (Plastiras type) of the EC I phase (e.g., fig. 10). The *head of the figure would have resembled that of the sitting figure in figure 8. New York, The Metropolitan Museum of Art 1972.118.104, Bequest of Walter C. Baker. Pres. H. 21.5 cm.*

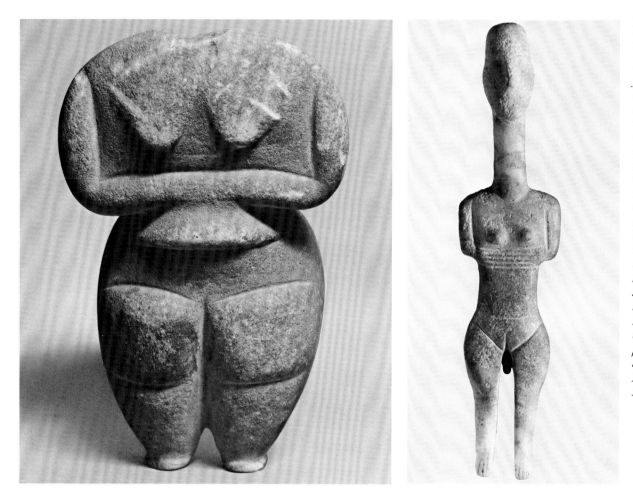

Figure 10. Female figure. Plastiras type. EC I.
Typical features of the Plastiras type seen on this figure include hollowed eyes, luglike ears, a sculpted mouth only barely visible because of weathering of the surface, an extremely long neck, long incised fingers which seem to double as a decorative pattern strongly reminiscent of postpartum wrinkles (e.g., figs. 6, 7), broad hips, and legs carved separately to the crotch. A cylindrical headdress or polos is suggested by the shape of the head on top. This may have been originally more clearly indicated with paint. Pasadena, Norton Simon Collection N.75.18.3.S.A. H. 18.5 cm.

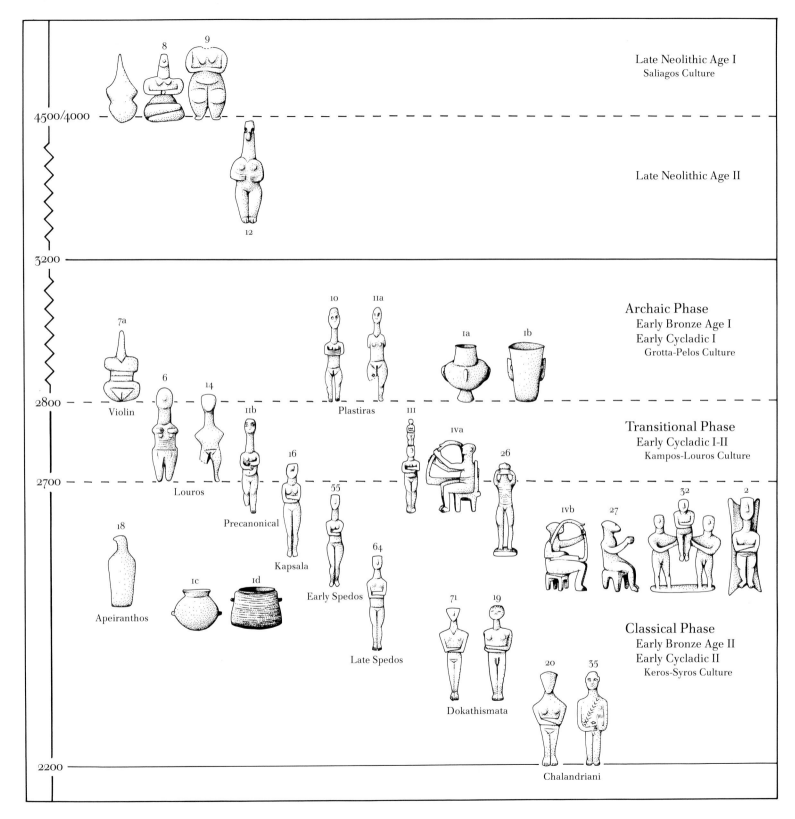

8
9

4500/4000

Late Neolithic Age I
Saliagos Culture

12

Late Neolithic Age II

3200

7a

10
11a

1a
1b

Archaic Phase
Early Bronze Age I
Early Cycladic I
Grotta-Pelos Culture

6
14

2800

Violin

Plastiras

Transitional Phase
Early Cycladic I-II
Kampos-Louros Culture

11b
III
IVa
26

Louros

16

2700

Precanonical

Kapsala

55

Early Spedos

18

1c
1d

64

IVb
27
32
2

Apeiranthos

Late Spedos

71
19

Classical Phase
Early Bronze Age II
Early Cycladic II
Keros-Syros Culture

Dokathismata

20
35

2200

Chalandriani

30

the first of the Bronze Age ones.

Cycladic sculpture may be divided, stylistically and iconographically, into two distinct groups, apparently with a transitional phase in between (fig. 11). These divisions correspond generally to the chronological and cultural sequences based on changes that occurred in Cycladic ceramics during the third millennium B.C.

The earlier group, whose relation to Neolithic antecedents we have been considering, might conveniently be called "archaic." The numerous schematic figures of this phase, many of them shaped like violins (fig. 7a, c), are characterized by a long, headless prong. Their rather rare representational counterparts (Plastiras type), besides retaining the Neolithic arm position and stance, also reveal a curious combination of exaggerated proportions and painstaking concern for anatomical detail, both on the face and on the body (fig. 10). Careful attention was paid to the kneecaps, ankles, and arches, while the navel and buttock dimples were also often indicated. Although for the most part the eye sockets are now empty, they

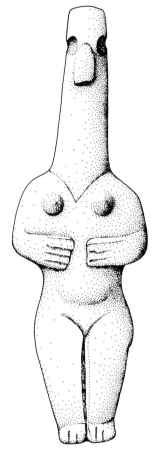

Figure 12.
A Neolithic standing figure with hollowed eye sockets that presumably once held inlays. New York, The Metropolitan Museum of Art L.1974.77.3 (on loan from Christos G. Bastis). H. 20.9 cm.

31

a. *See figure 8.* b. *See figure 9.* c. *See figure 45.* d. *See plate IIa.* e. *See plate IIb.*

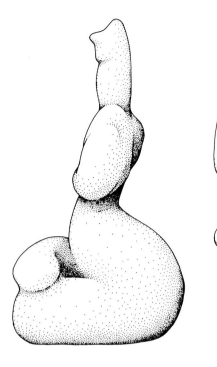
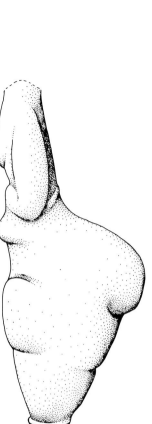

Figure 13. A comparison of the profiles of Late Neolithic (*a, b*), EC I Plastiras type (*c, d*), and EC I/II precanonical (*e*) figures.

were inlaid with dark stones (pl. v*a*), a practice for which there also may have been Neolithic precedents (fig. 12).

A new feature of these archaic figures is the complete separation of the legs from the feet up to the crotch. In the Neolithic figures, only the feet were carved as separate elements. Whatever the motive for this new practice, it carried a strong risk of accidental breakage to the legs, which often happened, perhaps during the carving process itself. Apparently these early sculptors did not mind; they simply brought into play one of their favorite implements—the hand-rotated borer. With the borer they normally made eye sockets, hollowed ears, navels, buttock dimples, and

occasionally even complete perforations at the elbows as well as the suspension holes in the lugs of the marble vases they produced in astonishing quantity at this time (pl. 1*a, b*). When a figure sustained a fracture, they also used the borer to make rather conspicuous holes through which a string or leather thong could be drawn to refasten the broken part (pl. 11*a*, fig. 45).

Although the archaeological record is uncertain at this point, it appears that Cycladic sculpture next entered a period of transition, Early Cycladic I/II (fig. 11). The first evidence of this change is the attempt by sculptors to fuse the abstract and the representational approaches. In the most common form, the figures have featureless heads, the incision work was kept to a minimum, and the problem of rendering the arms was avoided by making them simple, angular projections at the shoulders (figs. 6, 14). By contrast, the legs are often quite carefully modeled. As many as seven of these transitional (Louros type) examples have been found together in one grave.

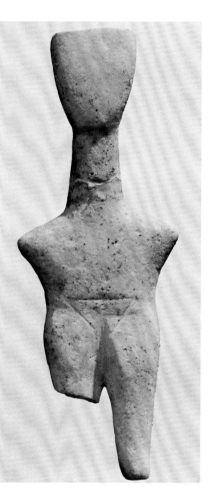

Figure 14. Female figure. Louros type. EC I/II. *Note the featureless face, the long neck, and the separately carved legs characteristic of the type. Evidence for the dating of such idols is at present limited to one grave, no. 26, at Louros Athalassou on Naxos, from which the type takes its name. In that grave, a group of seven figures was found standing in a niche. New York, Paul and Marianne Steiner Collection. H. 10 cm. Said to be from Naxos.*

a.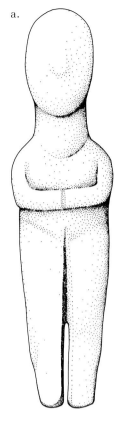

b.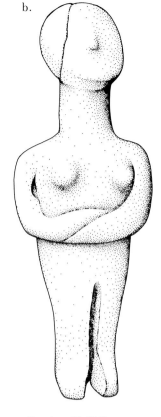

c.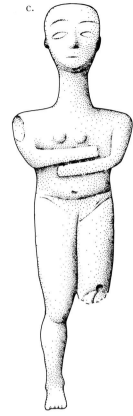

d.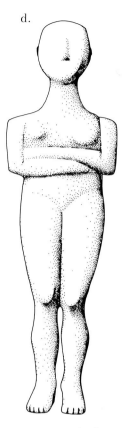

Figure 15. Four small, precanonical figures showing steps in the development of the folded-arm position. EC I/II.

a. *Although the arms are rendered in the manner of the Plastiras type, the proportions show none of the exaggeration of the earlier figures and the legs are not carved separately to the crotch. Private collection. H. 15.8 cm.*

b. *Norwich, University of East Anglia, Sainsbury Centre for Visual Arts, P9(d). H. 9.5 cm.*

c. *The arms are tentatively folded (cf. pl. IIb) but in an unorthodox right-above-left arrangement. The legs are separated to just above the knees. A mending hole for the re-attachment of the missing leg is visible in the left knee. Note the carved ears, the incised facial detail, the modeled legs, and the soles parallel to the ground, characteristics found on most of the best precanonical examples. Geneva, Barbier-Müller Museum BMG 202.9. H. 15.9 cm.*

d. *Although the arms are properly folded in the canonical right-below-left arrangement, the figure retains such precanonical features as carved ears, well-modeled legs separated to the knees, and soles appropriate to a standing posture. Houston, Menil Foundation Collection 73-01 DJ. H. 16.2 cm.*

Toward the end of the transitional phase, sculptors began to strive for more balanced and natural proportions (fig. 15, pls. 11*b*, 111). While unknowingly setting the stage for the emergence of the canonical folded-arm figure at the beginning of the second, "classical" phase (fig. 16), these sculptors were finding new ways to produce representational figures in quantity. At the same time, they were reducing the risks involved in the carving process. Along with more natural proportions, which resulted in sturdier figures, the sculptors seem to have been seeking an arm rendering more appropriate to the slender body type of their images. While the old Neolithic arm position of hands touching over the midriff may well have been suited to exaggerated corpulence, for the person of ordinary build to assume this pose involves moving the elbows and upper arms well away from the sides so that a large triangular clear space remains. This gap was sometimes hazardously indicated by perforations at the fragile bend of the arms. An interest in a natural pose carved in a secure way, rather than any new influence or shift in religious meaning or gesture, most likely inspired the gradual development of the folded-arm position that was to become *de rigueur* in the next phase (fig. 15). This new position entails no free space if the elbows and upper arms are held close to the sides. Indeed, the very early folded-arm figures seem to be tightly clasping themselves (fig. 16). In order to reduce further the risk of fracture, the legs are now separated for only about half their length, from the feet to the knees, or even less (pl. 11*b*). Beginning with these "pre-canonical" figures, repairs are much less frequently seen, presumably because there were fewer accidents in the workshop. Considerable attention was still paid to individual forms and to details, but less than in earlier phases.

Roughly contemporary with these transitional figures is the harp player in the Metropolitan Museum of Art. This work, with its allegedly un-Cycladic arm muscles and three-dimensional thumbs (pl. IV*a*), has often been condemned because it does not

Figures 16, 17. Female folded-arm figure. Kapsala variety. EC II. *An early example of the classic or canonical folded-arm figure. Note the "sensible" proportions, the elbows held close to the sides, the carefully modeled calves, and the sharply broken profile. Los Angeles, Los Angeles County Museum of Art M.74.1.B, Gift of Mr. and Mrs. Herbert Baker. H. 23.1 cm.*

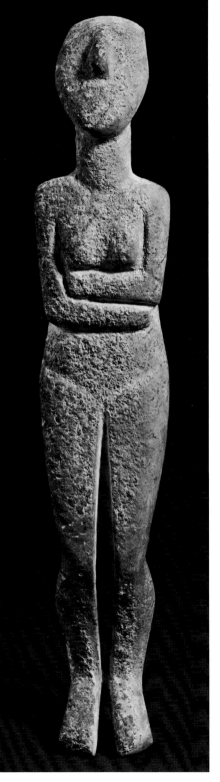
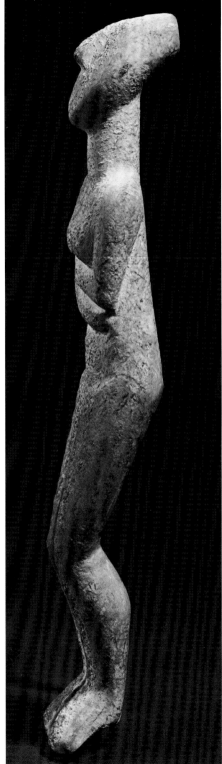

conform to what has come to be a restricted and circumscribed notion of what a Cycladic sculpture should look like. Attuned as one is to the harmoniously proportioned folded-arm figure (and to harpers carved in the same style—pl. IV*b*, figs. 23–25) and not to the little-known or little-admired precanonical images, it is difficult for some to accept the New York harper as a genuine Cycladic work. We need, however, to stretch our conception of Early Cycladic sculpture to include such forerunners of the images executed in the more fluid classical style. If one views the New York harper as a fine example of an essentially experimental movement, bearing in mind the bizarre Plastiras-type figures which came before in addition to considering that exaggerated proportions and attention to detail had not yet been entirely supplanted (pl. III), the harper falls naturally into place as the earliest known example of a rare type.

Early in the second or classical phase of Cycladic sculpture (Early Cycladic II), the full-fledged folded-arm figure emerges in several different varieties which, for the most part, appear in a specific chronological sequence (fig. 11). More simplified and streamlined than its predecessors, the canonical or folded-arm type was produced in astonishing quantity over a period of several centuries. Its abstract counterpart (Apeiranthos type) has a simple geometric body, with the neck carrying the suggestion of a head (fig. 18).

Unlike the figures of the archaic phase, the profile axis of the first folded-arm figures (Kapsala variety and some examples of the Early Spedos variety) is sharply broken, particularly at the back of the head and at the bend of the knees. The feet are held at an angle, outward and eventually also downward, in what appears to be a tiptoe position if the figures are set vertically (fig. 17). These features, however, are appropriate to a relaxed, reclining position, a distinct contrast to the erect posture of the archaic Plastiras figures (figs. 10, 13). The figures dating from the earlier period were evidently meant to stand, although they do not do so unsupported. Just as with the changes

Figure 18. Female (?) figure. Apeiranthos type. EC II.

The EC II counterpart of the violin figures of EC I, images of this type differ from the earlier ones in that they have the suggestion of a head and their bodies tend to be rectangular and devoid of incised markings. Sometimes carved in shell, they have been found in association with Spedos variety figures and were presumably made by sculptors who also fashioned such fully representational images. New York, private collection. H. 12.3 cm. Said to be from Keros.

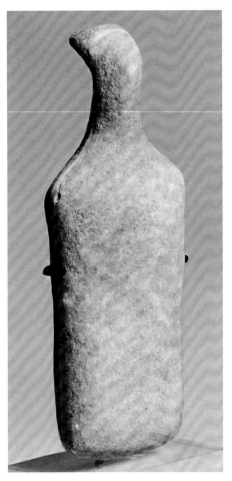

in arm position that took place about the same time, this altered posture probably does not indicate any radical change in religious symbolism or any external influence. Because it evolved gradually, it is more likely that the reclining posture was introduced by the sculptors themselves. Since the figures were normally laid on their backs in the grave, the sculptors may have assumed that they should be made in a reclining posture from the start. In any case, at this time another distinction was made: those figures intended to stand were furnished with small rectangular bases (figs. 26, 32), while seated figures were carved with their feet parallel to the ground (pl. IV, figs. 23, 24, 27, 28).

In the early folded-arm figures (Kapsala and Early Spedos varieties), the legs are joined by a thin membrane, perforated for a short space between the calves (figs. 2, 16, 55, 56). This practice seems to be a further attempt to strengthen the limbs at vulnerable points. As the folded-arm figures developed, however, the perforation of the leg cleft was usually omitted altogether (Late Spedos var-

Figure 19. Male folded-arm figure. Dokathismata variety. EC II.

Carved toward the end of the period of production, this rare male figure is noteworthy for its plastically treated brows and straight grooved hair—probably an exclusively male hairstyle—as well as for the separation of its upper arms from the chest, effected by means of oblique cuttings. As in most examples with arm cutouts, at least one of the upper arms has broken off. The damage in this case is old, but whether it occurred at the time of manufacture, shortly thereafter, or much later cannot be determined. It is clear, however, that broken arms could not have been easily reattached, for which reason such cutouts, however attractive, were not often attempted. New York, The Metropolitan Museum of Art 1972.118.103b, Bequest of Walter C. Baker. H. 35.9 cm.

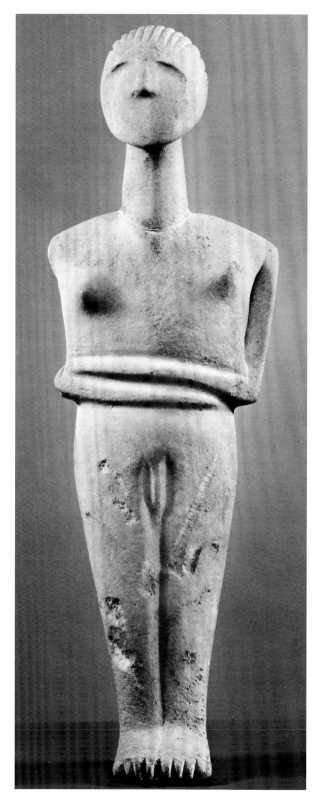

iety; figs. 3, 44, 49), no doubt in an effort to reduce the risk of fracture still further. In the latest and most hastily executed examples, the legs (which by now have a straight profile) are separated merely by an engraved line (Dokathismata and Chalandriani varieties; figs. 19–22, 35, 36). Because of the risk, only a few sculptors of such very late works perforated the leg clefts of their figures or dared to free the slender upper arms from the sides (figs. 19, 21, 22b).

From the beginning of this second phase, the folded arrangement of the arms became a strictly observed convention. Not only are the arms folded, but also, for several centuries and with very few exceptions, they are folded in one arrangement only: the right arm is shown below the left. Some might interpret this as having mystical connotations, but it is possible that the convention was established unwittingly by a few right-handed sculptors who found it easier to draw the arms in this pattern. Having set the lower boundary of the arms by drawing the right one, the sculptor could easily fill in the lines of the left arm above, leaving himself a clear view of the right one. Once the practice was started, other sculptors presumably would have followed suit.

After the eye has been trained by looking at a large number of figures, any departure from the right-below-left formula strikes one as decidedly odd—quite wrong, in fact (fig. 2). Not unexpectedly, forgers of Cycladic figures, as well as copiers for the Greek tourist trade, not infrequently arrange the arms in the opposite fashion: right above left. They probably do so out of a failure to appreciate just how strictly the convention was observed.

Toward the end of the classical period, the canonical arm arrangement no longer dominated, as is evident in the Chalandriani variety. Although a limited revival of interest in the carving of facial detail and hair occurred at this time (fig. 19), sculptors generally lavished less care on their works, which also tended to be quite small. The figures became highly stylized renderings with distorted proportions and severe, angular outlines. The traditional arm arrangement was often ignored or misunder-

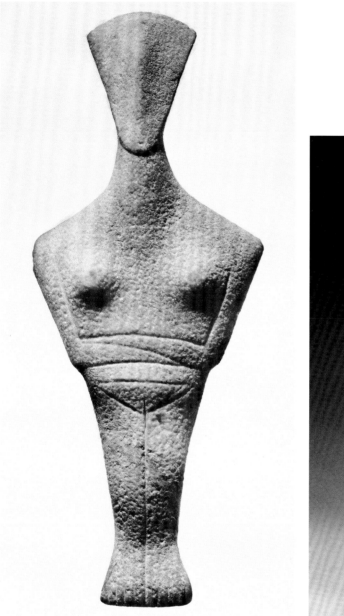

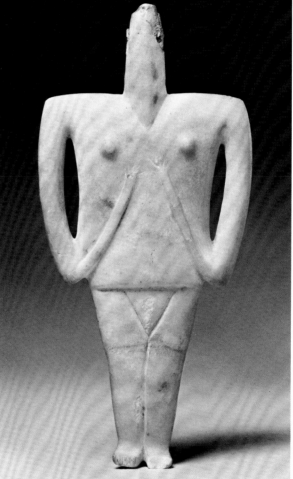

Figure 20. Female folded-arm figure. Chalandriani variety. EC II.
Name-piece of the Stafford Master. An unusually fine example of the final folded-arm variety, the figure is noteworthy for its highly stylized outline in which curving and angular lines are boldly counterbalanced. Several other works can be attributed to this talented sculptor. Cambridge, The Fogg Art Museum, Harvard University 63.1985, on loan from the Frederick Stafford Collection. H. 27 cm.

Figure 21. Female figure. Chalandriani variety. EC II.
The figure is unusual both for the uncanonical position of the forearms and for its arm cutouts. The head, now missing, was once reattached by means of lead clamps set in channels on either side of the break. Apart from this example, lead as a mending agent in the EC period is only found on pottery. New York, The Metropolitan Museum of Art 1977.187.11, Bequest of Alice K. Bache. Pres. H. 27.3 cm.

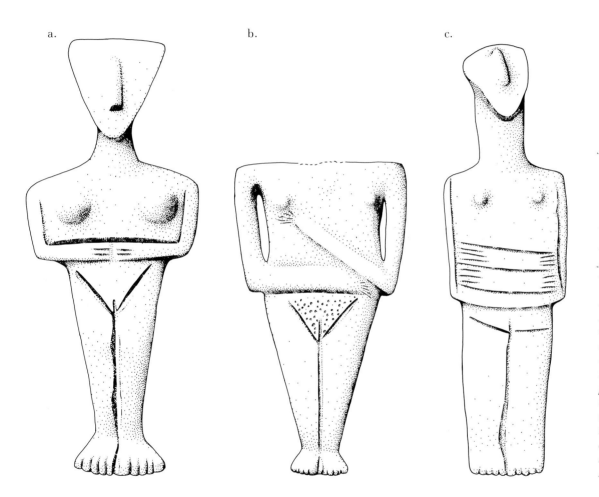

a.

b.

c.

Figure 22. Three Chalandriani variety figures with uncanonical arm arrangements. EC II. a. *The arms are rendered in the old Plastiras position (cf. fig. 10), but the resemblance is probably fortuitous. The angular lines and the absence of a midsection are features typical of the Chalandriani variety. Private collection. H. 30.2 cm.* b. *Note the arm cutouts and scratched fingers (cf. fig. 21) and the unusual stippling of the pubic triangle. London, British Museum 75.3–13.2. Pres. H. 23.6 cm.* c. *Said to be from Seriphos. Carved in an unusual blue-gray marble, the figure is most probably the work of an untutored person living outside the sculptural mainstream. East Berlin, Staatliche Museen, Antikensammlung Misc. 8426. H. 22.2 cm.*

Figure 23. Two male figures. Harper type. Kapsala variety style. EC II.

A charming pair, clearly designed as companion pieces, they were reputedly found together with a footed vessel of marble carved of a piece with a little table that closely resembles their stools in size and shape. Note the typical duck's bill ornament of the harps which are held, also typically, on the musicians' right sides. In contrast to the Metropolitan Museum's harper (pl. IVa), who is shown using only his thumbs to make music, these harpers are shown plucking the strings with all the fingers of at least the right hand. While the left hand of figure b probably held the harp frame (both the left hand and a section of the harp are missing), figure a must have been shown plucking the strings with the left hand as well. Differences in hand position as well as in the type of furniture represented were the sort of liberties allowed in the execution of an otherwise very rigidly defined type. New York, private collection. H. 17.4 cm and 20.1 cm. Said to be from Amorgos.

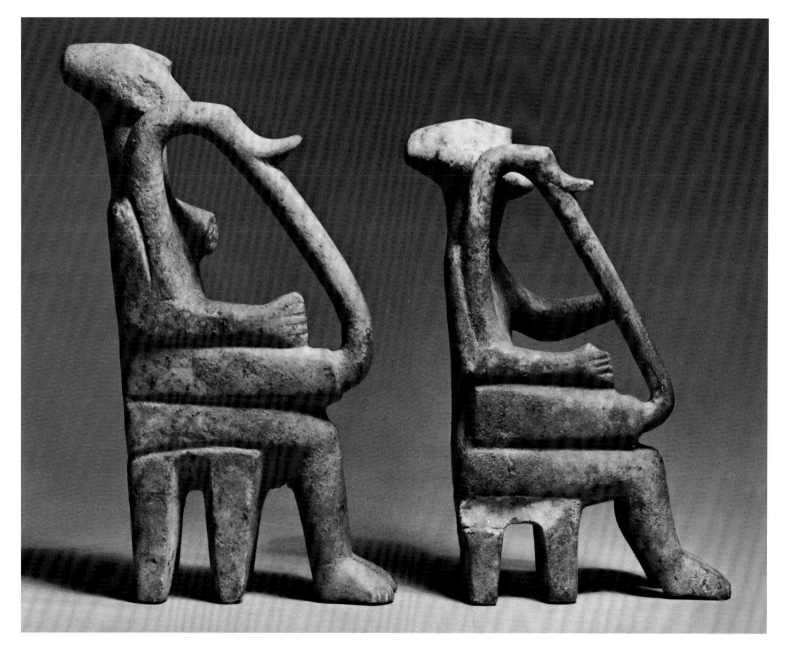

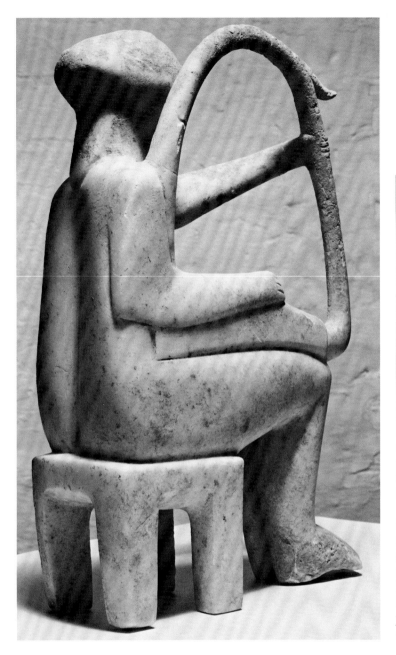

stood (figs. 21, 22). An extreme example is a clumsy figure which appears to have three arms and four sets of fingers (fig. 22c).

The beginning of the second Early Cycladic phase was a time of prodigious output and of startling self-confidence and virtuosity, analogous to the ambitious developments in large marble sculpture that took place in the Cyclades some two thousand years later. Although a few examples are stylistically slightly earlier (pls.

Figure 24. Early Spedos variety style harp player. EC II. *See plate IV b.*

Figure 25. Detail of figure 24. *See also plate IV b.*

III, IVa), most of the rarely attempted special figure types belong to this phase.

First and foremost are the musicians, the seated harpists and standing woodwind players (figs. 23–26, pl. IV). Other seated types include the cupbearer and variations of the standard folded-arm female (figs. 27–29). Also included are the scarce two- and three-figure compositions. In one two-figure arrangement, a small folded-arm figure is carved on the head of a larger one (pl. III). In another, of which no complete example survives, two figures of the same size are set side by side clasping each other about the shoulders (figs. 30, 31). A variation of this theme is the amazing three-figure group carved in a single piece, in which the standing male figures link arms to support a seated female (fig. 32).

Nearly all the exceptionally large figures were also carved at this time (figs. 4, 34). While a number of fragments of such monumental figures survive (fig. 33), very few complete ones are known. From the largest extant example, found in a grave on

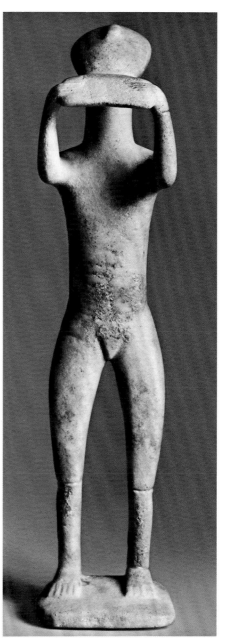

Figure 26. Male figure. Woodwind player type. Kapsala variety style. EC II.
An unusually well-preserved example of a very rare type, this figure is presently perhaps also the earliest one known. It is unusual both for its slenderness and for its articulated ribcage. The musician plays a sandwichlike syrinx (panpipes), which in reality is an instrument of roughly trapezoidal shape, though the Cycladic sculptor has translated it for his own purposes into a symmetrical form. Karlsruhe, Badisches Landesmuseum 64/100. H. 34 cm.

Figure 27. Male figure. Cupbearer type. Early Spedos variety style. EC II. *This engaging work is the only complete example of its type. At present only a fragment of one other is known. As with the harp, the cup is held on the right side, while the left arm is held against the body in the canonical folded position. Like the Early Spedos variety folded-arm figures in whose style it is carved, the cupbearer's legs are rendered with a perforation between the calves. Athens, Goulandris Collection 286. H. 15.2 cm.*

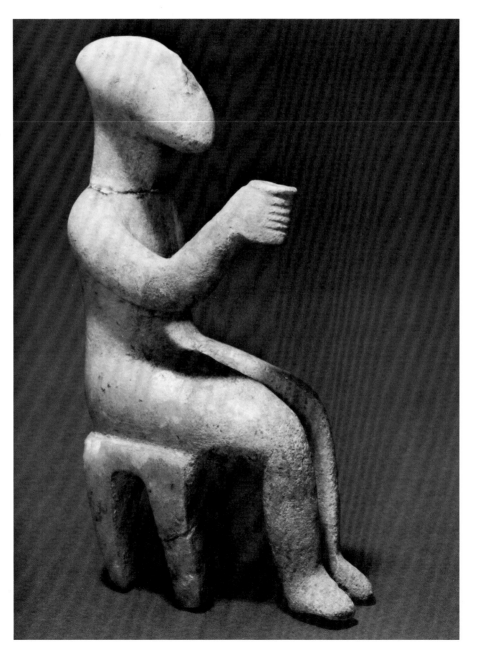

Figure 28. Female folded-arm figure seated on stool. Early Spedos variety style. EC II.
This work was among the seven seated female figures (of a known worldwide total of only nine or ten) recovered in recent excavations at Aplomata on Naxos. Found with two standard folded-arm figures, it was stolen shortly after being unearthed and has not been recovered. (Any information regarding its present location would be most welcome and should be addressed to the writer.) The figure and its companion in the Naxos Museum are at present unique for their crossed feet. Note the difficulty encountered by the sculptor in indicating the pubic area; on seated males (e.g., figs. 23, 27) the genitalia are often absent altogether, perhaps because of the difficulties involved. H. 12 cm. (Permission to publish photo courtesy C. Doumas).

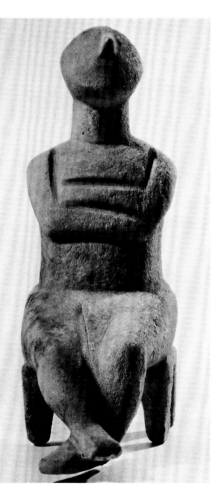

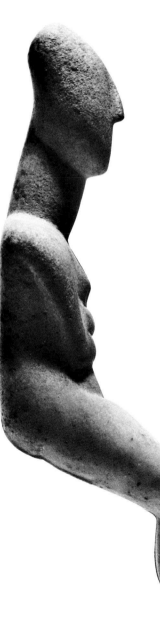

Figure 29. Female folded-arm figure in semi-sitting position. Early Spedos variety. EC II.
One of only three or four examples executed in this peculiar position, this carefully worked figure originally may have had a wooden seat, or earth may have been made into a seat-shaped mound to enable it to sit in a more or less upright position. Another possibility is that it was originally part of a three-figure composition like figure 32. New York, private collection. H. 19 cm.

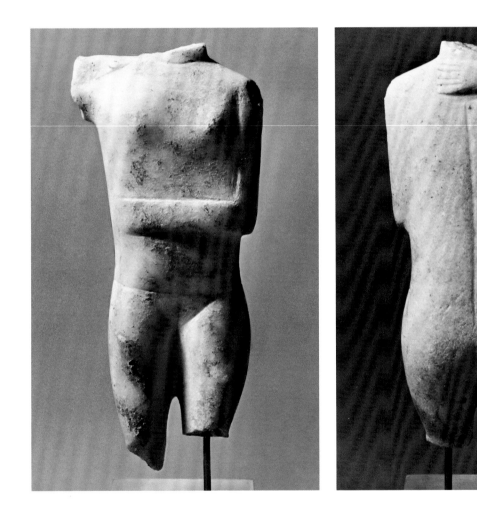

Figures 30, 31. Female figure. Double type. Spedos variety. EC II. *This is one of several examples in which only part of one member of a duo survives with the arm of the second carved across its back. Of these, there are only two with enough preserved so that the sex can be determined. In this group we know that one figure is female, but we cannot ascertain the sex of the other. As with the cupbearer type (fig. 27), it is noteworthy that the free arm is held in the canonical position folded across the body. It is probable that such compositions were normally furnished with bases; indeed, bases that evidently supported two figures have been unearthed on Keros. Karlsruhe, Badisches Landesmuseum 82/6. Pres. H. 17 cm.*

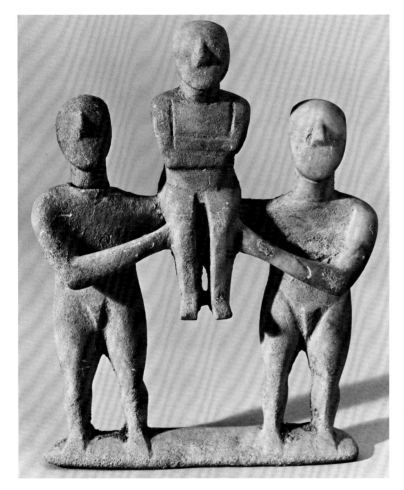

Amorgos, we know that such nearly life-size works were at least sometimes broken into several pieces in order to fit them into the grave, which was normally no larger than necessary to accommodate the corpse in a severely contracted position.

There is an interesting distinction of roles observed in males and females in Early Cycladic sculpture. The female is always represented in a passive and, in terms of current body language theory, aloof attitude, regardless of whether she is standing, reclining, or sitting, or whether she is single or doubled. On the other hand, the male figure is more often than not depicted in an active role. In the earlier part of the classical period, as we have seen, he takes the role of cupbearer, musician, or strongman who, with a companion, holds aloft a quietly sitting female. Toward the end of the period, he is outfitted with the accoutrements of a hunter or warrior. At that time his most noticeable piece of equipment is always a baldric, though he may also carry a small dagger and/or wear a belt with codpiece (figs. 35, 48a).

Figure 32. Three-figure composition. Early Spedos variety style. EC II. *This is probably a recurring type within the repertoire of the Cycladic sculptor, but because of the great difficulty involved, no doubt the composition was attempted only very rarely. This work is the only known example. It is at least conceivable, however, that certain other pieces originally belonged to similar compositions (e.g., figs. 29–31). Karlsruhe, Badisches Landesmuseum 77/59. H. 19 cm.*

Figure 33. Fragmentary female folded-arm figure. Early Spedos variety.
EC II.

The rather worn torso belonged to an exceptionally long, slender figure measuring well over 100 cm. It is noteworthy not only for its size but also for its quite naturalistic and sensitively rendered upper arms. The work can be attributed to the same sculptor who made the somewhat larger piece illustrated in figures 4 and 34, with which it shares a similar rendering of the arms and hands, complete with fine wrist lines. (The largest known figure, in Athens, is perhaps also the work of this sculptor.) Brunswick, Maine, Bowdoin College Museum of Art 1982.15.4, Bequest of Jere Abbott. Pres. H. 28.6 cm.

Figure 34.
Detail of figure 4.

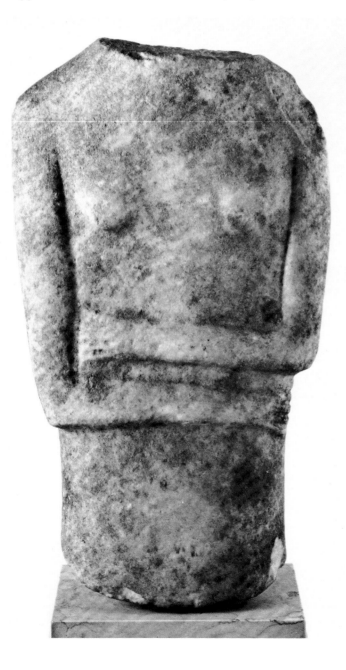

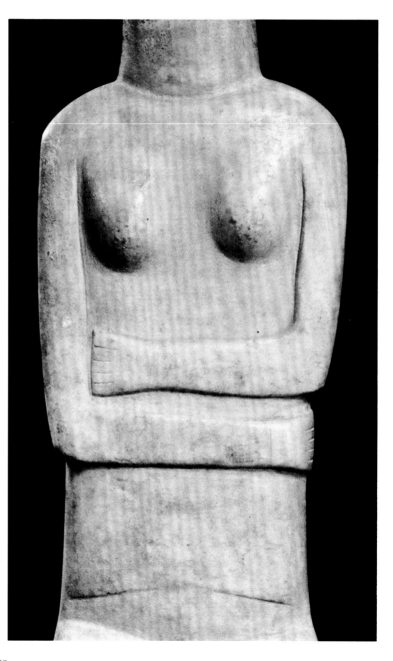

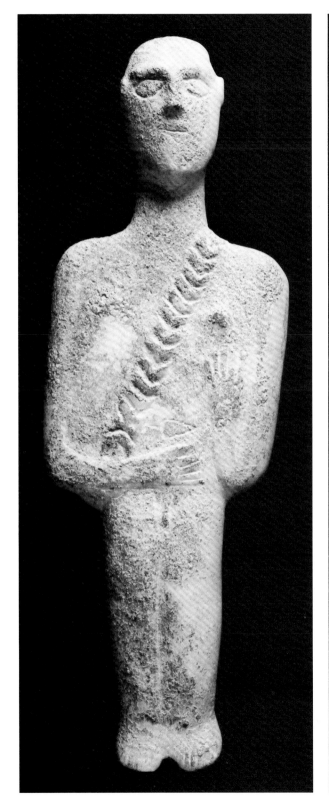

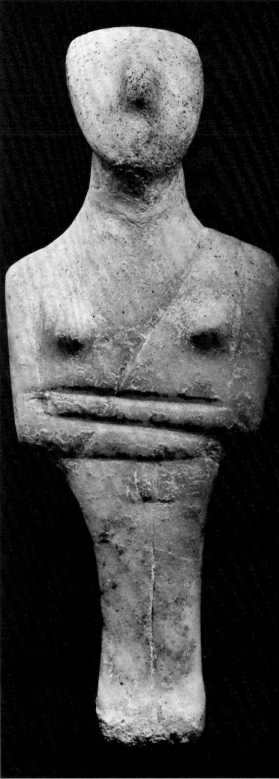

Figure 35. Male figure. Hunter/warrior type. Chalandriani variety. EC II.

Lacking the taut angularity of outline normally associated with the Chalandriani variety, this figure is interesting as an example of a rather rare occupational type of which it is also one of the most detailed. Note the rather haunting facial expression, the carefully incised ornamentation of the baldric, and the leaf-shaped dagger "floating" above the right hand. The figure was allegedly found on Naxos together with a slightly smaller female companion. (Drawings made in the mid-nineteenth century of a very similar pair were discovered recently by J. L Fitton in the British Museum. The present whereabouts of these sculptures remain a mystery.) Athens, Goulandris Collection 308. H. 25 cm.

Figure 36. Male folded-arm figure with baldric. Chalandriani variety. EC II.

Rather poorly conceived and carelessly executed, the figure is nevertheless of interest for the manner in which it was evidently converted from a female into a male image by the addition of baldric and penis. Fingers, haphazardly scratched, were probably also added at the same time. Seattle, Seattle Art Museum 46.200, Norman and Amelia Davis Classic Collection. H. 19 cm.

Figure 37.
Detail of figure illustrated in figures 56 and 57 showing paint ghosts on the back of the head preserved as a light, smooth surface. See also plate Vb and figure 38.

Figure 38.
Detail of figure 37. Note the little "tails" on the neck.

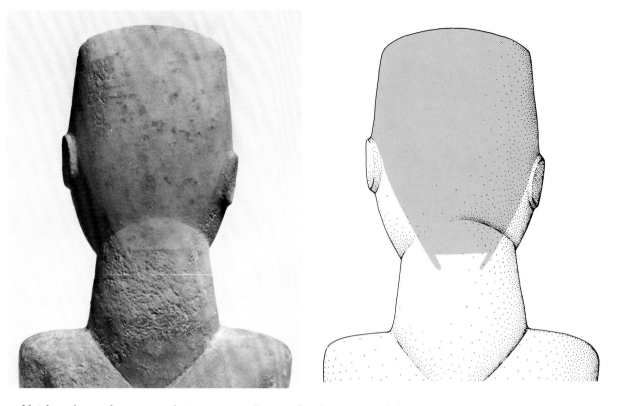

Neither the sculptors nor their customers seem to have been very particular about their figures at this late date. There are examples in which quite ordinary female folded-arm figures seem to have been perfunctorily transformed into males by the simple addition of a hastily incised penis and, more noticeably, an incised or merely scratched diagonal line on the chest and back to indicate the baldric. Apparently, it did not matter that the baldric was added as an afterthought and cuts across the arms (fig. 36).

Except for the nose and the ears on a few very large works (figs. 41, 56–59), there is normally a complete absence of sculptural detail on the face and head of canonical folded-arm figures and on the other figures executed in the same classic style (pl. vc, d). Those who have difficulty imagining or accepting the fact that Greek sculpture and buildings were once richly painted will, similarly, prefer to think of Cycladic figures as most of them have come down to us—pure form reduced to bare essentials and executed in a cool, moonlike whiteness.

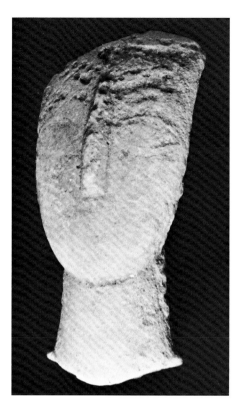

Figure 39. Head of a folded-arm figure. Late Spedos variety. Probably a work of the Goulandris Master. EC II.
The badly damaged head, which belonged to a figure measuring 60 cm or more, is of interest chiefly for its well-preserved paint ghosts for eyes and hair (fig. 40). Malibu, The J. Paul Getty Museum 83.AA.316.2. Pres. H. 10.4 cm. Said to come from Keros.

Figure 40.
The back and side of the head illustrated in figure 39, showing raised paint ghosts for hair with depending curls.

However, most, if not all, of these images and at least some of their archaic antecedents originally received some painted detail which would have altered their appearance considerably.

The red and blue pigment is itself only rarely preserved, but many figures show paint "ghosts," that is, once-painted surfaces which, because they were protected by pigment, now appear lighter in color, smoother, and/or slightly raised above the surrounding areas which are generally in poorer condition (pl. IVa). In certain cases the ghostlines are so pronounced that they can easily be mistaken for actual relief work (pl. Vb).

Most often the painting took the form of almond-shaped eyes with dotted pupils, solid bands across the forehead, and a solid area on the back of the head to indicate a short-cropped hairstyle (figs. 37, 38). Less often curls, depending from the solid area, were painted on the sides and back of the head (figs. 39, 40), and dots or stripes decorated the face in various patterns (pl. VIa, c; figs. 42, 77). Only one figure known at present

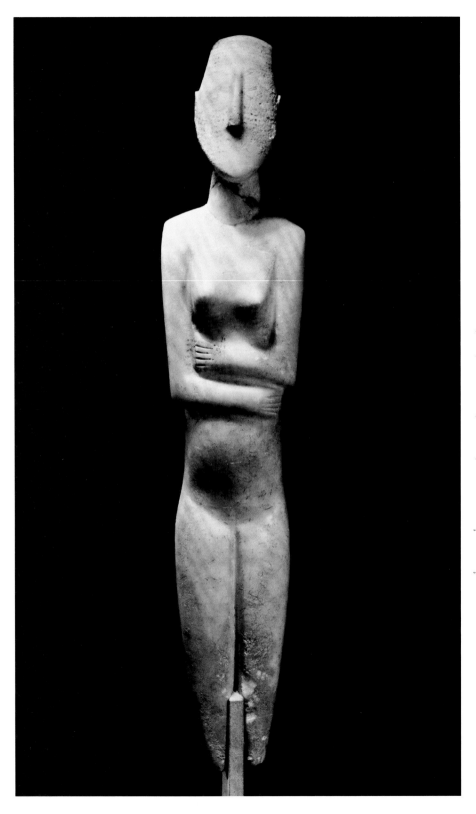

Figure 41. Female folded-arm figure. Kapsala variety. EC II.
This unusually large and exceptionally fine example of the Kapsala variety stands out among all known Cycladic sculptures for its superb modeling and for the wealth of painted detail still present on the head and body. Although there is clear evidence of painted eyes, brows, hair, facial tattooing, bangles, and pubic triangle from a number of other works (albeit not all on the same piece), the painted necklace seen here is unprecedented. It is not entirely certain that a mouth was once painted on this figure. New York, private collection. Pres. H. 69.4 cm. See also plate VIa, b, figure 42.

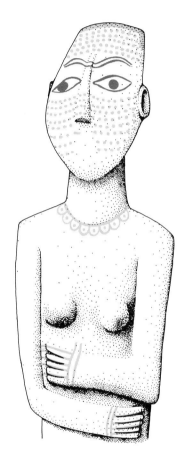

has painted ears (pl. VI*d*), while few, if any, show clear traces of a painted mouth. The apparent omission of the mouth would accord well with the sepulchral nature of the figures. Occasionally paint was also used to emphasize certain grooves on the body (pl. VI*b–d*), to define or emphasize the pubic triangle (figs. 41, 56, 58), or to depict bangles and other adornments (pl. VI*b*).

Although with time the actual paint has largely disappeared from the sculptures, bone canisters and little clay pots containing lumps of coloring matter are sometimes found in Cycladic graves, as are palettes and bowls intended as mortars for pulverizing the pigments, which were derived from ores of iron (hematite), mercury (cinnabar), and copper (azurite) indigenous to the islands. It would appear, therefore, that ritual face painting was an important part of the religious rites observed by the islanders, and the patterns they used on their sculptures may well reflect those they used on themselves and hoped to perpetuate in the afterlife.

Figure 42.
*Detail of work illustrated in figure 41 (and pl. VI*a, b*) showing the face and body painting.*

Figure 43.
Copy of the female folded-arm figure in figure 44 carved by Elizabeth Oustinoff in an experiment using Parian marble and tools made from Naxian emery, Melian obsidian, and Theran pumice. A fracture sustained during the initial shaping of the piece necessitated an alteration of the original design so that the finished work, intended at the outset to be somewhat larger than the model, does not closely resemble it except, accidentally, in size. Such mishaps probably occurred with some frequency in ancient times as well, but it would appear that sculptors preferred to repair or otherwise salvage their works rather than discard them to begin again. A dramatic example may be seen in figure 54. H. 17 cm.

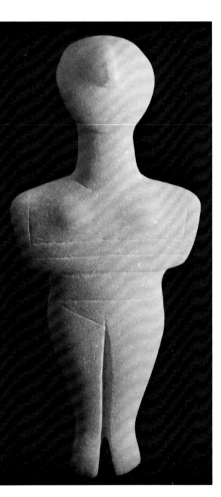

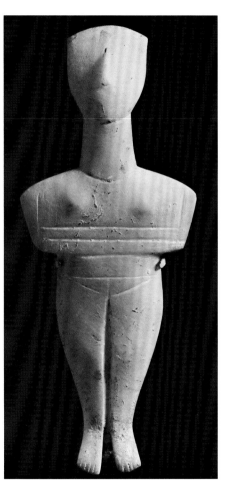

Figure 44. Female folded-arm figure. Late Spedos/Chalandriani variety.
EC II.
A well-made figure of modest size, the work belongs basically to the Late Spedos variety, but its broad shoulders and upper torso and its short midsection are more characteristic of the Chalandriani variety. Note that the right arm/hand extends all the way to the left elbow in order to make the rendering symmetrical. (On the rear, the left elbow is carved on the back of what in front is the right hand, again for the sake of symmetry.) Zürich, Mr. and Mrs. Isidor Kahane Collection. H. 17.5 cm.

The Formulaic Tradition

We have reviewed rather hastily some six or seven centuries of sculptural activity, with key developments illustrated by a mere example or two. Perhaps the single most important point to be stressed, however, and one which is difficult to appreciate without a plethora of examples, is the remarkable adherence to a standard form. Of the many hundreds of extant pieces of Early Cycladic sculpture, there are only a very few that do not belong to one of the established types or do not contain elements of two sequential varieties. Despite a vast array of subtle differences and a wide variation in quality, Cycladic sculptures are essentially formulaic in character. There are no freely conceived pieces. Even those special pieces such as the harp players had their own formulae and strict design rules. Once established, each traditional type, each highly formalized set of conventions, was adhered to with almost imperceptible changes for centuries.

The way the figures were made can shed some light on their final similarity. It must have been a laborious process, one involving constant yet careful chipping away and abrading of the stone. Pieces of emery from Naxos (one of the world's major sources of this mineral) were probably used for this purpose, while emery or obsidian from Melos would have been used to make incisions, sand and perhaps pumice from Thera to smooth the stone (fig. 43). One can easily imagine the sculptor's workshop by the sea where he could have found much of his raw material already partially worked for him by the action of the waves. For a drawing pad he could have used the wet beach sand and, to polish his works, the pumice that washed up on the shore following eruptions of the Thera volcano. Nevertheless, at all times his own patience and diligence must have been his most valuable assets in bringing a work to completion.

The sheer labor involved in the production of any but the simplest small figures must have precluded a haphazard or spontaneous approach. Marble, though not a hard stone, clearly lacks the malleability of clay or the tractable qualities of wood. In

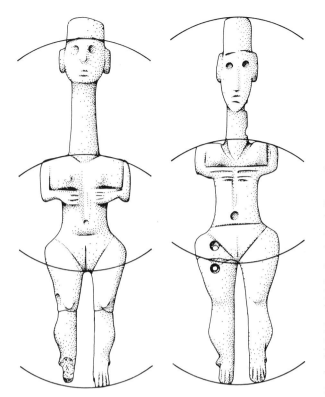

fact, marble tends to crack and break quite easily and thus requires a highly disciplined approach if irremediable errors are to be avoided. It appears that formulae were developed to aid the Cycladic sculptor in carefully composing his figure on the slab before he actually began to carve. Probably evolving out of necessity, such formulae may also have imbued the sculptor's craft with a certain mystique. They doubtless served as oral and visual vehicles for the transmission of the sculptural tradition, the sculptor's ritual, from one generation to the next.

In examining some of the rules that seem to have governed the manner in which the figures were designed, one can see just what it is, besides the uniform treatment of the arms or legs or face, that makes one Cycladic idol of a particular type or variety so closely resemble any other of its kind. Unfortunately, no slabs or blocks of marble have been found which could provide evidence of the formulae or the devices used to inscribe these initial designs. Nevertheless, an examination of a large number of finished works has revealed recurring patterns, making it quite reasonable to postulate the use of particular formulae and certain basic aids—compass, protractor, ruler—before carving was begun.

In the first or archaic phase, the human form was divided into three equal parts: roughly one part for the head and neck, one for the torso, and one for the legs (fig. 46*a*). These three divisions could have been made with a simple ruler, but what seems to have been more important was the placement of certain key features based on

Figure 45. A comparison of the designs of two works attributed to the Metropolitan Museum Master, a sculptor of Plastiras type figures of the EC I phase.

a. *Name-piece of the sculptor. The broken right leg was reattached in antiquity, mending holes having been bored through the side above and below the knee. New York, The Metropolitan Museum of Art, Rogers Fund, 45.11.18. H. 21.6 cm. See figure 13c.*
b. *The figure has repair holes through the neck (sideways) as well as in the right thigh. Geneva, Barbier-Müller Museum BMG 202.75. H. 18.3 cm.*

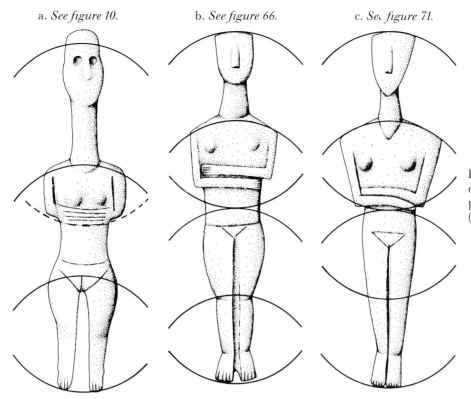

a. *See figure 10.* b. *See figure 66.* c. *See figure 71.*

Figure 46. The two major design canons of the EC period: EC I, three-part (*a, c*); EC II, four-part (*b*).

this outline. For example, the shoulders and hips were evidently blocked out by means of arcs drawn with a primitive compass consisting of a bit of obsidian or even charcoal attached to a piece of string. The radius of the circle that determined the arc was one third of the body length. An arc passing through the midpoint of the figures was often used to define the position of the elbows.

Even though the body was schematically divided into three equal parts, the proportions within those parts might vary considerably. Figure 45, for example, shows two works attributable to the hand of one sculptor called the Metropolitan Museum Master. Both figures were designed according to the three-part plan, but with some important differences. In the name-piece, the pill-box hat or *polos* was added to the three-part scheme, whereas it was an integral part of the design of the other figure. On the New York idol (*a*), the sculptor carved a relatively short head on a very long neck. On the other figure (*b*), he did just the opposite: the head is elongated; the neck, for this exag-

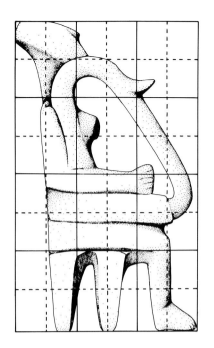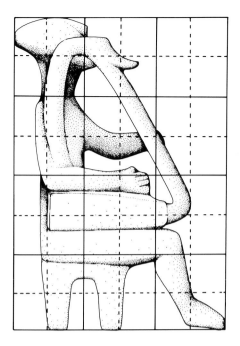

Figure 47.
*Grid plans based on the
standard four-part plan.
See figure 23.*

gerated type, is rather short; and the remainder of the top division is filled out by the headdress. Similarly, the name-piece has an ampler chest area but a shorter waist than the other work, yet within this middle division is contained the entire torso of each of these figures. The proportions might vary, therefore, even in two figures carved by the same person, while the basic tripartite formula tended to remain remarkably constant.

In the classical period of Cycladic sculpture, the design formula appears to have changed to accommodate a more natural approach to the human form. The earlier folded-arm figures (Kapsala and Spedos varieties) were now conceived as divisible into four equal parts, with a maximum width often equal to one part (fig. 46*b*). Compass-drawn arcs marked off the shoulders, the elbows or waist, and the knees. The top of the head and the ends of the feet were also curved, revealing further the influence of the compass. Once again, within the basic divisions there was room for variation and individual difference.

More complex works produced at this time seem to be modifications of the four-part scheme, while the virtuoso pieces—the harp players, the cupbearers, and the triple group—seem to have benefited from more elaborate planning. The seated figures, for example, appear to have been treated more as four-sided works

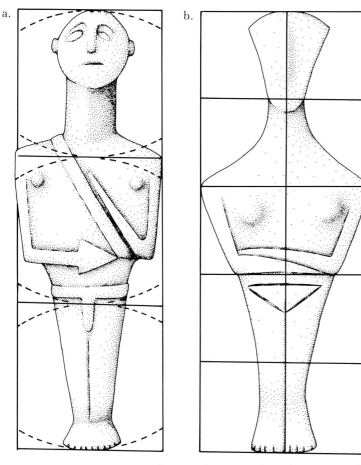

a.

b.

further subdivided to form a grid of eight by six "squares." The lines of the grid tended to coincide with key points on the outline as well as with internal divisions, such as the chin, the elbow, the cup, and the top of the seat. A substantial number of the same coincidences recur from piece to piece; additional coincidences are noticeable in the works attributed to the same sculptors (fig. 47).

Of the figures produced late in the second phase (Dokathismata and Chalandriani varieties), few fail to give some indication that they were designed according to a consciously applied formula (fig. 46c). However, as with the canonical arrangement of the arms, the four-part plan, though still the preferred one, was not the only one in use; some sculptors evidently tried other designs, using, for example, three- and five-part divisions (fig. 48). By now it would seem that the compass was generally considered inappropriate for the severely angular style of these images.

Altogether, roughly one-half of all Cycladic figures appear to have been quite carefully conceived according to

Figure 48. Three- and five-part designs of the late EC II phase.
a. *Male figure. Hunter/ warrior type. Dresden, Staatliche Kunstsamm-lungen, Skulpturensamm-lungen ZV 2595. H. 22.8 cm. Said to be from Amorgos.*
b. *See figure 20.*

than as integrated sculptures in the round. The most important side is invariably the right one, the side on which the harp or cup is held. It appears that a grid plan was consistently applied in the design of these works. The grid was based on a division of the height into the usual four primary units, while the width was made to approximate three of these units. The height and width were

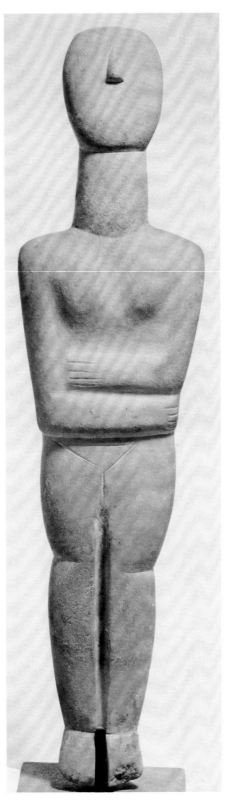

Figure 49. Female folded-arm figure. Late Spedos variety. A work of the Naxos Museum Master. EC II.
Characteristic features of the style of this somewhat idiosyncratic and prolific sculptor seen on this piece include a small, high-placed nose, generalized breasts, thick forearms which lie directly above the pubic area, and rather careless incision work. Note the uneven lengths and widths of the fingers, the uncentered pubic triangle, and the knee incisions cut at different levels. The work of the Naxos Museum Master has been found in three different cemeteries on Naxos, where it may be assumed he lived and worked. New York, Woodner Family Collection. H. 51.4 cm.

a.

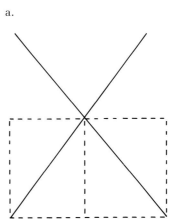

b.

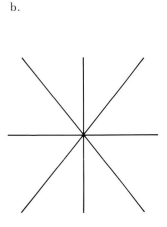

a specific design formula. The other half seems to have been less thoughtfully planned or at least less rigorously executed according to the original design laid out on the raw slab. Some seem not to have benefited from any logical plan. Many of these are of inferior quality, carved perhaps by nonspecialists. There are also a number of idols executed by proficient sculptors who seem to have found it to their liking and certainly well within their capabilities to alter the rules to suit their own personal aesthetic. Some sculptors, for example, elongated the thighs to an exaggerated degree, making the calves and feet rather short by comparison (fig. 55). Others preferred to omit the midsection of

Figure 50a, b.
The harmonic system: angles derived from a 5:8, or golden, triangle (or rectangle).

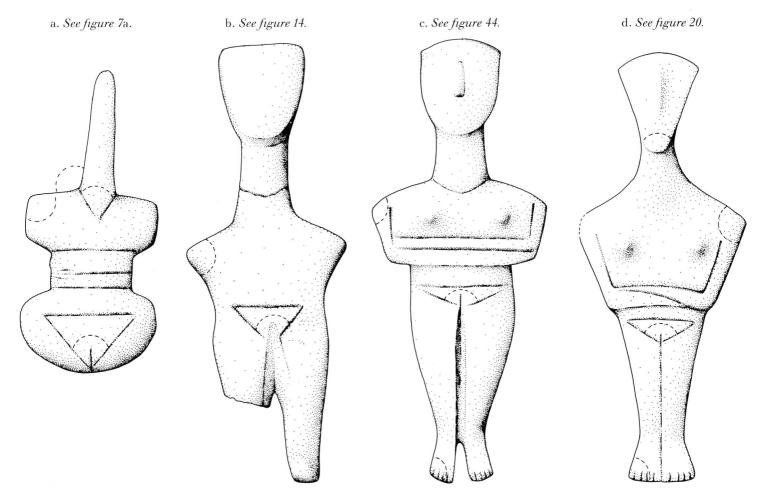

a. *See figure 7a.* b. *See figure 14.* c. *See figure 44.* d. *See figure 20.*

their figures, placing the pubic area directly below the forearms (fig. 49). This decision required an adjustment of the standard formula: the midpoint now occurs at the arms or higher rather than at the abdomen.

Another controlling factor in the formulaic planning of all the figures, even the simplest ones, appears to have been the repeated use of several angles based on the principle of the golden triangle found frequently in both art and nature (fig. 50a). Recent experiments conducted by the author suggest that virtually everyone has an innate preference for at least one or a combination of two of the angles in the configuration illustrated in figure

Figure 51.
Harmonic angles and their combinations used for certain features on the outline and for internal details.

50*b*. Asked simply to draw one or more isosceles triangles that they considered "pleasant," without any reference to particular anatomical features, thirty-eight out of forty-one individuals produced one or more of these angles, in most cases with surprising accuracy. These same angles were used in Cycladic sculpture for the contours of certain features, such as the shoulders, and for internal details, such as the pubic "V" or triangle (fig. 51), and served as a major homogenizing influence within each type.

It should be evident by now that the Cycladic sculptor's craft was a sophisticated one. It seems most unlikely that ordinary farmers and sailors could, as a rule, have made their own marble figures. As mentioned earlier, most islanders either did without idols altogether or at most made do with figures fashioned from wood which they could have whittled for themselves at no expense. More likely, the formulaic nature of the idols, the exquisite craft demonstrated in many, and the occasional experimentation with the formulae point to a class of sculptors who specialized in carving idols and vessels which would give their owners pleasure in life and comfort in the grave.

The Individual Sculptor

There is no evidence to suggest that there were workshops on the Cycladic islands in which several sculptors labored side by side. Nor is it possible to distinguish the styles of different island "schools," if indeed such existed. It seems likely that the larger communities on these islands, and probably some on a few other islands, tended in each generation to support one or two sculptors or, more likely, a sculptor and his apprentice, who was, in most cases, probably his own son (fig. 52). Through trade or travel, some of their works would have found their way to other settlements and at least occasionally to other islands. The figures of some of these artists have turned up in excavations at different sites, and in some cases at sites on more than one island (e.g., Naxos and Paros; Naxos and Keros). It is possible too that some of these sculptors were itinerant craftsmen, although most probably stayed home, eking out a living from the soil and practicing their craft part-time.

While it is not feasible to isolate workshops or local schools, it is now possible to recognize the hands of a substantial number of individuals. To identify the works of individual Cycladic sculptors can be quite easy, since some of them made figures that are nearly exact replicas of one another. Sometimes the figures of one artist are very similar to one another in overall appearance although in size they may differ appreciably. In other cases, ascriptions are not easily made.

The extent to which figures of one type carved by one sculptor resemble one another would have varied, of course, from master to master and even from piece to piece. Some sculp-

Figure 52.
"Marble John" working on a gravestone made from stone hewn from the mountainside on the outskirts of Apeiranthos on Naxos in 1963. The village marble carver, he learned his craft from his father, "Marble George." Although the marble working tradition may not have been continuous from the third millennium B.C. to the present, the need for such craft specialists and the passing on of the traditions from father to son seem, nevertheless, to have changed but little over the millennia.

Figure 53. Fragments of folded-arm figures representing the Spedos, Dokathismata, and Chalandriani varieties.
EC II.
A representative sampling from the "Keros hoard," a huge assemblage of sculptures, mostly fragmentary, said to have been recovered more than two decades ago on Keros. During systematic exploration, closely similar material was recovered; abundant signs of previous exploitation were also noted, making it all the more likely that the hoard did indeed come from Keros. Several sculptors whose work is illustrated here are represented among the finds from Keros and/or the Keros hoard, including the Stafford (fig. 20), Goulandris (figs. 39, 60–68), and Naxos Museum (fig. 49) Masters. Malibu, The J. Paul Getty Museum 83.AA.316.1–2, 83.AA.317.1–3, 83.AA.318.1, 83.AA.201, 78.AA.407, and Southern California private collections. Pres. H. 7.5–19 cm.

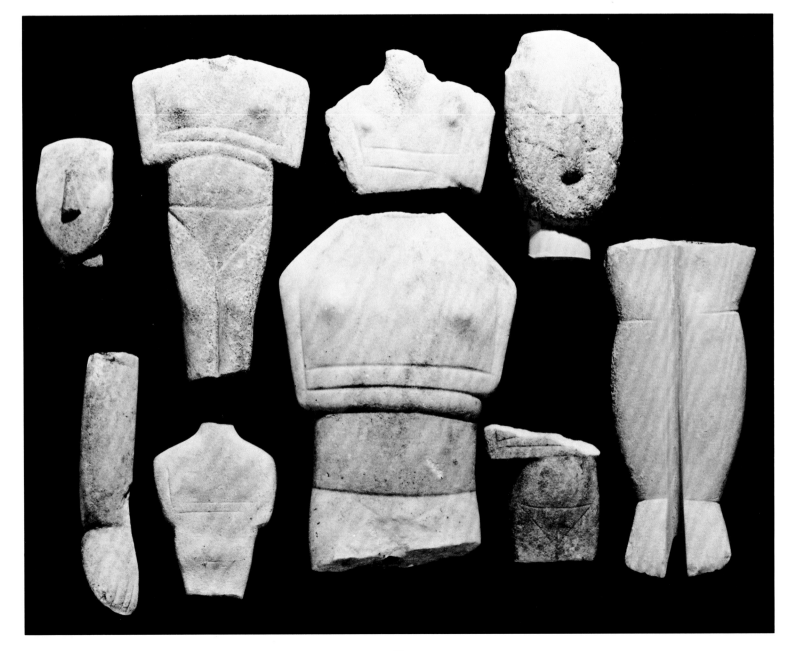

tors may have been content to carve essentially the same piece over and over again; others may have found it expedient to duplicate past work on occasion; but at least several sought, either deliberately or unconsciously, to experiment and refine their styles. Many factors could have influenced the degree to which two figures, executed by the same artist, would have been similar or dissimilar, not the least of which would have been his own general disposition as well as his feelings in relation to making a particular piece. Other contributing factors may have been the sculptor's innate talent and skill level, the care with which he approached his work, and the consistency of his methods. The particular piece of marble chosen for a figure, the shape of the tools used in the carving process and, in some cases, even an accident easily could have influenced the final appearance of a piece (figs. 43, 44, 54, 55).

The single most important consideration, however, was time. Some sculptors may have worked on two or more figures concurrently. It might be expected that such works would have been virtual duplicates, particularly if they were conceived as companion pieces. For example, in the case of group compositions we know that sculptors strove to make the matching members of each work identical (pl. III, fig. 32). Figures carved independently but relatively close in time, or figures modeled on past work kept on hand, would be likely to resemble each other to a greater degree than would works carved at a considerable interval in time from each other. One would expect to find major changes among pieces representing different phases of a sculptor's artistic development, so that if the accidents of preservation were such that only a very early and a mature work of one sculptor had been brought to light, the two images might prove quite difficult to attribute to a single hand. There is, of course, also the possibility that some sculptors altered their styles so drastically from piece to piece or from phase to phase that we can have no hope of ever attributing a reasonably complete body of work to them. But so many changes would more likely

Figure 54. Female folded-arm figure. Early Spedos variety. A work of the Copenhagen Master. EC II.

The carefully executed and unusually large figure is of special interest because of its strangely truncated legs and odd, vestigial feet which contrast sharply with the balanced proportions and attenuation seen in the rest. This incongruity most probably resulted from irreparable damage sustained by the figure, possibly during the carving process, at what was to have been the knees, according to the original design. Rather than abandon what may have been a nearly completed piece, the sculptor simply telescoped the entire length of the legs and feet into the space, unusually elongated in any case, originally allotted to the thighs only. See figure 55 for another figure carved by the Copenhagen Master which was completed in the normal manner. Athens, Goulandris Collection 257. H. 70 cm. (As originally conceived the figure would have measured about 85 cm.)

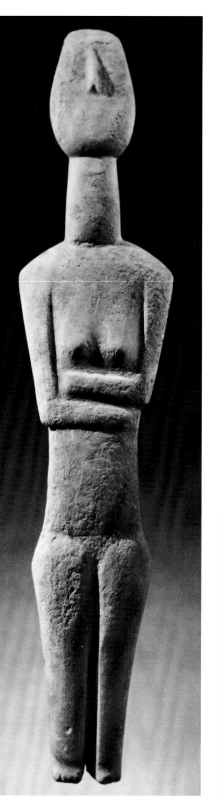

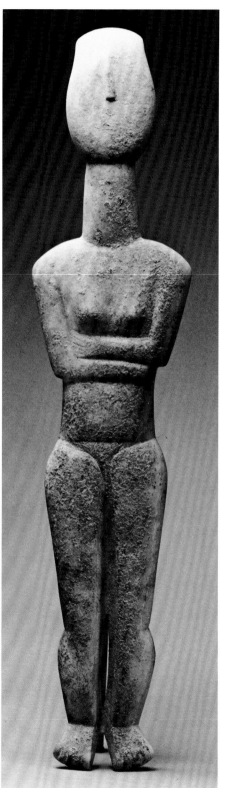

Figure 55. Female folded-arm figure. Early Spedos variety. A work of the Copenhagen Master. EC II.

Considerably smaller and with a much less elongated torso than the preceding figure (fig. 54), this work nevertheless shares with it certain close similarities of contour and detail and gives one a good idea how the legs of the large image were originally conceived. New York, private collection. H. 56.2 cm.

have been the exception rather than the rule.

The possibility of identifying the works belonging to different points in a sculptor's career or to different stages in his development is dependent on two important factors. One is the external control imposed by the tradition, which dictated in very specific terms how a figure of a given type or variety was to be designed and executed. The other is the unconscious, internal control exerted by the artist's personal style. While every figure shares in the highly conservative, formulaic style of its period, it also carries its sculptor's personal stamp or "signature."

This signature may be defined as a recurring complex of characteristics which, though often easier to appreciate visually than to describe verbally, reveals the works of one sculptor to be stylistically closer to one another than to the works of any other sculptor. The characteristics vary from master to master, and no two sculptors are precisely alike in the way they express their individuality. Certain techniques of execution,

forms or details, even errors or omissions, aspects of the outline contours, certain angles, a particular adaptation of the canonical design or, most likely, a combination of some or all of these characteristics remains for the most part unchanged or varies in a predictable way from image to image within the oeuvre of one master. That is to say, the basic concept remains the same while the individual's style evolves.

Most probably no single feature is unique to one sculptor's style. Originality, or rather individuality, consisted of a particular choice or combination of features, while excellence would have depended not on innovation but rather on the harmonious integration of these familiar elements, a high level of skill in their execution, and great care in the finishing and painting of the surface. Artistic growth and, in the case of a relatively small number of sculptors, excellence would have evolved gradually through the repetitive experience of carving many examples of the same type or variety.

Earlier, we looked at the two ar-

Figures 56, 57. Female folded-arm figure. Early Spedos variety. A name-piece of the Karlsruhe/Woodner Master. EC II. *One of the largest virtually complete figures now known, the work is unusual for its carved ears and very clear paint ghosts for eyes, brows, and hair. (Note the asymmetrical placement of the ears and eyes.) The pubic area was probably also painted. New York, Woodner Family Collection. H. 86.3 cm. See also figures 37, 38, and plate Vb.*

chaic figures of the Metropolitan Museum Master and noted how they were similar in abiding by a certain formula, specifically the three-part division of the body, yet differed from each other with respect to proportions within those divisions (fig. 45). Now it is necessary to look at the classical period and concentrate not so much on how an artist was controlled by tradition but on how he created his own personal style within that tradition and how his style is reflected in different works.

The Karlsruhe/Woodner Master

Consideration of individual style may begin with an examination of the two works at present attributable to a sculptor of the early classical phase called the Karlsruhe/Woodner Master (figs. 56–59). Nearly identical in length and exceptionally large, the two figures share a number of characteristics whose combined presence cannot have been fortuitous even though they differ in obvious ways. Although the Woodner piece is much

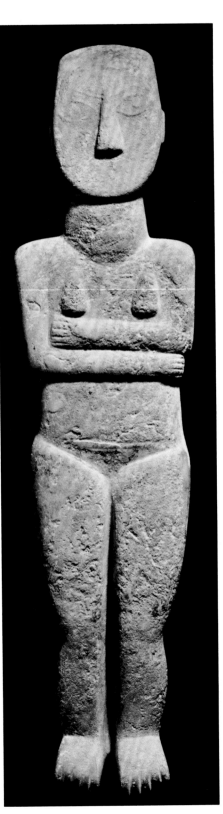
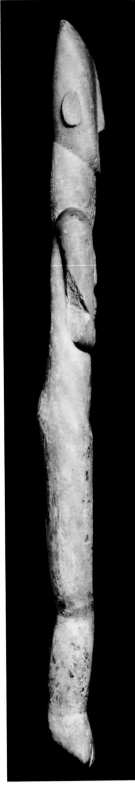

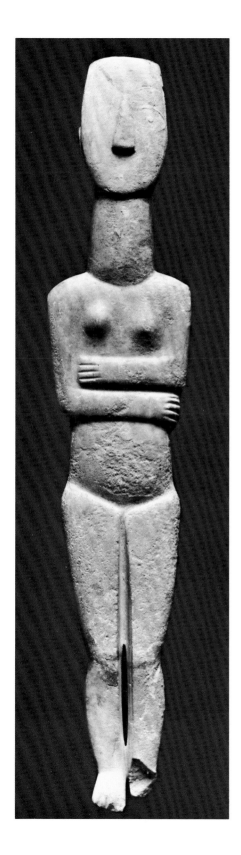

stockier in build and exhibits somewhat different proportions than those of the figure in Karlsruhe, the basic forms and contours are very close. Similarly executed details worthy of mention are the carved ears and the shape of the nose as well as their asymmetrical placement; in addition, the eyes and hair are now clearly discernible in the form of paint ghosts (pl. v*b*, figs. 37, 38). The pubic area, also rendered in a similar fashion in a plane slightly below that of the thighs, was probably once a blue-painted triangle, as suggested by traces of the original marble skin on both figures.

The main difference in detail is the treatment of the breasts: the flat teardrop-shaped breasts of the Woodner idol are unprecedented in classical Cycladic sculpture. The representation of breasts as pendent disappeared after the Neolithic period and may, in this case, be the result of an experiment or an attempt to cover up accidental damage. Wrist grooves, clearly incised on the Karlsruhe piece, are missing from the Woodner figure but may have been indicated in paint.

Figures 58, 59. Female folded-arm figure. Early Spedos variety. A namepiece of the Karlsruhe/Woodner Master. EC II. *Like the preceding work (figs. 56, 57), this is one of the largest virtually complete figures now known and is unusual for its carved ears and clear paint ghosts on the face. Karlsruhe, Badisches Landesmuseum 75/49. H. 88.8 cm.*

More importantly, the figures differ in structure. The Woodner idol is somewhat thicker in profile than the one in Karlsruhe, but the most noticeable discrepancy is in relative width: the former has a shoulder span slightly more than twenty-five percent of its length, while the latter has a width slightly less than twenty percent. One-quarter of the body length was the preferred ratio for the shoulder width in figures of small and average size, but most sculptors reduced the width to one-fifth or less for their large works (fig. 76). A narrower figure would have more comfortably fit the hands not only of the sculptor but those of bearers as well, and it would also have significantly reduced its weight, an important consideration if the sculpture was to have been carried easily to the gravesite. The Woodner figure weighs thirty-five pounds, while the slightly longer but thinner and narrower Karlsruhe piece by comparison weighs only twenty-three.

In the absence of more examples from this sculptor's hand, one can only speculate that the Woodner figure, which is heavier, more compressed in its "vertical" proportions, somewhat less carefully modeled, and more two-dimensional than the Karlsruhe image, was the earlier of the two works. How much so one cannot say. It may have been a relatively early attempt on the part of the sculptor to execute a figure on such a grand scale. In doing so he seems simply to have made a large version of the standard figure without addressing the matter of increased bulk and weight as he did on the Karlsruhe piece. On the other hand, one could argue that the increased mass of the Woodner figure represents a deliberate effort to heighten its monumental presence.

The Goulandris Master

In striking contrast to the Karlsruhe/Woodner Master is the Goulandris Master, who comes somewhat later. At present he is known from nearly one hundred pieces, although it is not certain that all of these are from different works. Thirteen of his figures are preserved in their entirety or very nearly so. Named for the Greek private collection that contains two of

his complete figures and a head, he is the most prolific Cycladic sculptor known and, after his initial efforts, one of the very finest. It can be assumed that he enjoyed considerable popularity and influence in his own time, to judge from both the quality of his works and their wide distribution: his figures have been found on Naxos, Keros, and, apparently, on Amorgos.

Although by no means exact reproductions of one another, each of the Goulandris Master's works is easily identifiable as the product of a single hand (figs. 60–68). Some features of his personal signature are a long, semiconical nose on a long, lyre-shaped face with painted decoration (figs. 39, 40); markedly sloping shoulders; precise parallel incisions curving gently at the neck, abdomen, knees, and ankles; an unperforated leg cleft; and a rounded back normally without the usual grooved spine. Other repeated elements of this master's style are not as easy to describe in words. So distinctive is the Goulandris Master's style, however, that it is possible to recognize his hand even in a small fragment and, with some confidence, to reconstruct from it a whole figure.

The Goulandris Master carved figures in an unusually wide range of sizes. The smallest measures about six and a half inches (16.5 cm), while his largest known work, of which only the head survives, is nearly six times as big. The large figures tend to be more ambitiously conceived than the smaller ones: they are planned more accurately according to the standard four-part plan (fig. 46b); they exhibit more pronounced modeling of the arms; the contours of the abdomen and thighs curve more strongly; the forearms are sometimes separated by a clear space; and the fingers are sometimes incised. Because the smaller pieces (16.5–40 cm) tend to be thicker in profile, straighter in outline contour, and lacking in unusual embellishment, they should generally be regarded as products of an early phase of the Goulandris Master's development (figs. 60, 61). The greater care lavished on the larger figures (55 cm or more) and their greater refinement point to a late or mature phase

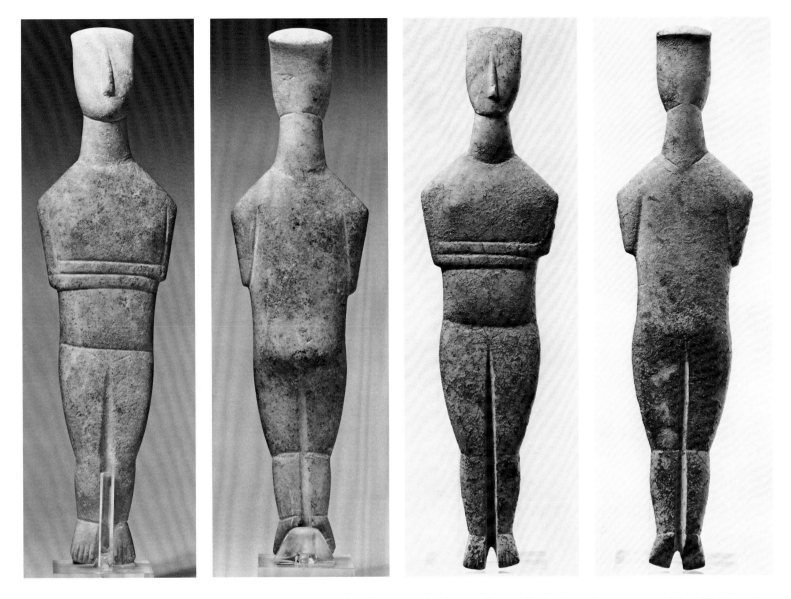

Figures 60, 61. Female folded-arm figure. Late Spedos variety. A work of the Goulandris Master. EC II.
A figure of above average size for the Spedos variety as a whole but rather small for the Goulandris Master, the work, which belonged to the Keros hoard, was reassembled from three fragments. In the process of obscuring

the joins, the restorer has obliterated the original grooves at the base of the neck and at the knees in front. The shortness of the calves, the forearms rendered almost solely by incision, and the straightness of the abdominal groove, considered together with the figure's modest size, are indications that it belonged to an immature phase of the

sculptor's artistic development. San Francisco, The Fine Arts Museums of San Francisco 1981.42, William H. Nobel Bequest Fund. H. 33.4 cm.

Figures 62, 63. Female folded-arm figure. Late Spedos variety. A work of the Goulandris Master. EC II.
On the basis of its delicate head and nose and better proportions, this figure is more advanced than the preceding one (figs. 60, 61), but the lack of modeling of the forearms suggests that it is not as developed as the next two

pieces (figs. 64–67) and should therefore be considered an intermediate work of its sculptor. New York, private collection. H. 42 cm.

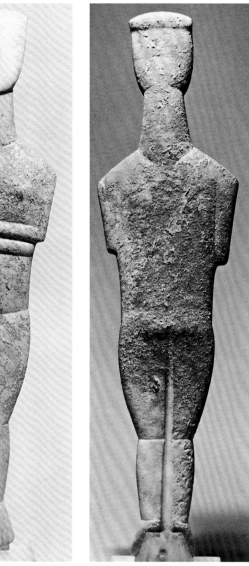

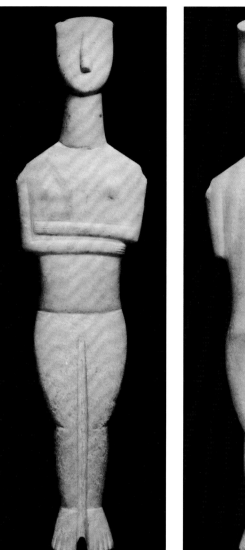

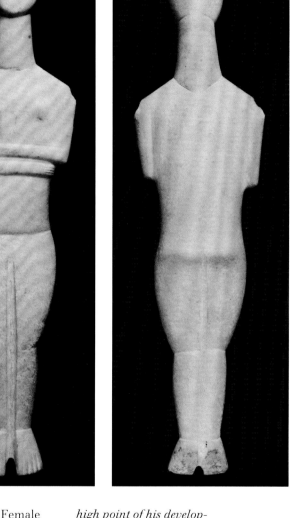

Figures 64, 65. Female
folded-arm figure. Late
Spedos variety. A work of
the Goulandris Master.
EC II.
*The large size, carefully
modeled and separated
forearms, and harmonious
proportions (cf., e.g., the
feet with those of the two
preceding works) indicate
a mature phase of the
sculptor's development.
Bloomington, Indiana*

*University Art Museum
76.25, Gift of Thomas T.
Solley. H. 60 cm.*

Figures 66, 67. Female
folded-arm figure. Late
Spedos variety. A name-
piece of the Goulandris
Master. EC II.
*With its carefully modeled
and separated forearms,
precisely incised fingers,
strong, subtly curving
contours at the waist and
thighs, and carefully
balanced proportions, the
figure represents the
Goulandris Master at the*

*high point of his develop-
ment. (The curious
markings on the right side
of the chest and on the
neck and back may be the
remains of painted deco-
ration.) Athens,
Goulandris Collection 281.
H. 63.4 cm. Said to be
from Naxos.*

Figure 68. Fragment of a female folded-arm figure. A work of the Goulandris Master. EC II.

While the piece as preserved appears well proportioned and carefully executed, the rendering of the arms primarily by incision and the size (about 50 cm originally) indicate that it should be assigned to an intermediate phase of the sculptor's career. The fragment is one of several dozen works from the hand of the Goulandris Master belonging to the Keros hoard (see figs. 39, 53, 60, 61). His work has also been found in the authorized excavations on Keros as well as in the cemetery of Aplomata on Naxos. It is very likely that he was a Naxian. Southern California, private collection. H. 18.5 cm.

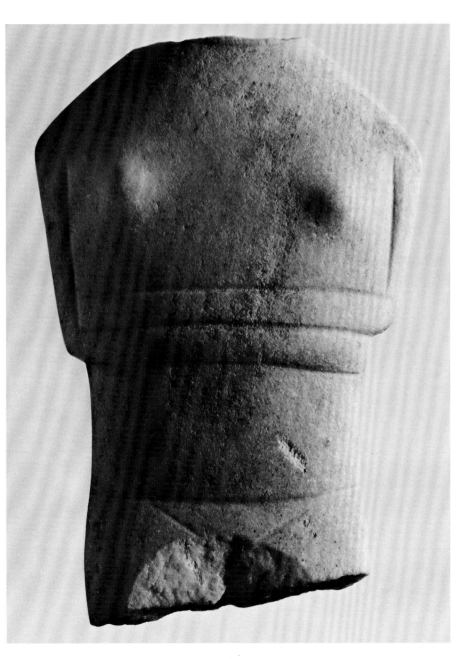

of the sculptor's career (figs. 64–67). To a middle phase might be assigned a number of well-balanced, carefully executed works of substantial size (40–60 cm) which lack such refinements as separated forearms and incised fingers (figs. 62, 63, 68).

The Ashmolean Master

The hand of a third sculptor can be recognized at present in only four complete works. In his prime also an excellent artist, he comes somewhat later in the sequence of folded-arm figures than the Karlsruhe/Woodner and Goulandris Masters. At first glance—especially if seen in actual size—the three figures (figs. 69–74) appear significantly dissimilar to one another, and one may well wonder how they can be ascribed to the same hand. But if they are lined up side by side in order of increasing size and studied closely, one soon sees that they all share certain unmistakable features. These include a shield-shaped face with a long, narrow aquiline nose originating high on the forehead, a V-shaped incision at the neck,

a small pubic triangle and, on two of the figures, only four toes on each foot. (On the fourth complete figure as well as on a fragment, this same inaccuracy is observable.) One should note, too, the indented waist and the subtle curve of the forearms—a convention used to represent or, in this sculptor's work, accentuate a pregnant condition. These and other shared features define the particular style of the Ashmolean Master, a sculptor named for the home of his largest known figure.

The Ashmolean Master's largest sculpture is three times the size of the smallest. The two middle figures (of which only one is illustrated here, figs. 71, 72) are very similar both in style and in size, each about half as long as the name-piece. And again, like the work of the Goulandris Master, the smallest figure of the Ashmolean Master (figs. 69, 70) has an unrefined look when compared with the others. The largest figure (figs. 73, 74) differs from the other three both in the application of the four-part formula and in its relative narrowness. This exaggerated slim-

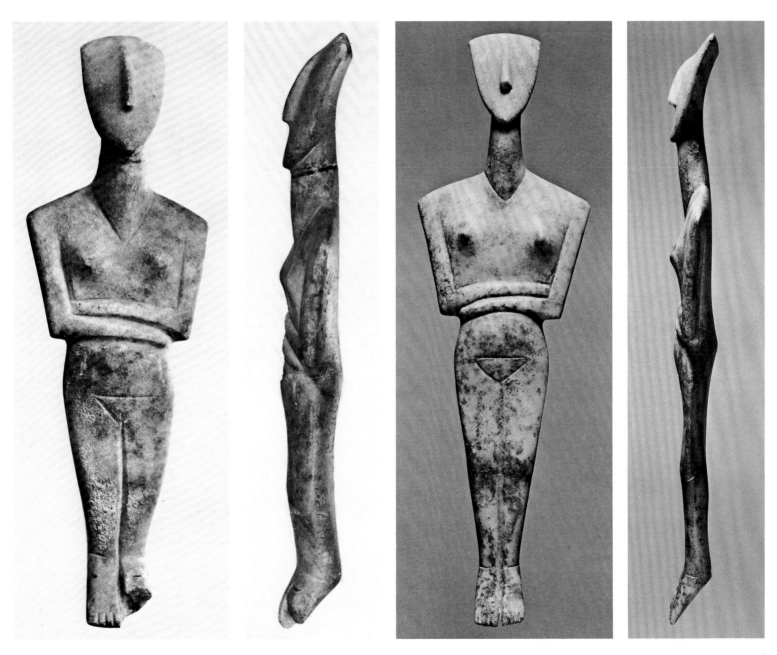

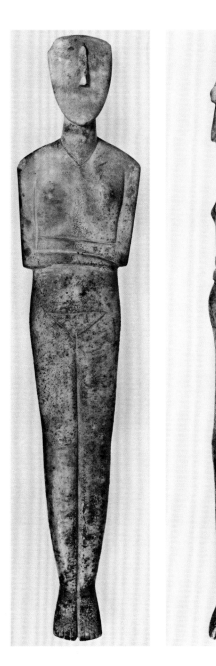

Figures 69, 70. Female folded-arm figure. Dokathismata variety. A work of the Ashmolean Master. EC II.
A rather small figure with a thick profile and somewhat crude incision work (see e.g., the leg cleft), this is the earliest sculpture attributable at present to the Ashmolean Master. Budapest, Musée des Beaux-Arts 4709. H. 23.7 cm.

Figures 71, 72. Female folded-arm figure. Dokathismata variety. A work of the Ashmolean Master. EC II.
Masterfully conceived and executed, the work represents the high point of the sculptor's development. Note especially the subtle interplay of angular and curving contours and the precise detail. Houston, Dominique de Menil Collection. H. 36.7 cm. Said to be from Naxos.

Figures 73, 74. Female folded-arm figure. Dokathismata variety. Name-piece of the Ashmolean Master. EC II.
On this unusually large work (it is the largest known example of the Dokathismata variety), the sculptor elongated the legs but not the upper part, with somewhat ungainly results. In contrast to his smaller works (figs. 69–72), which are extremely broad across the shoulders as befits the Dokathismata variety, this figure is narrow through the shoulders, with the result that its upper arms have a straight contour in contrast to the inward slanting contour of the two preceding figures. (Note that the mending of a break has obliterated the original ankle incisions.) Oxford, Ashmolean Museum AE.176. H. 75.9 cm. Said to be from Amorgos.

ness was, as mentioned above, common in exceptionally large images.

One can see in the works ascribed to the Ashmolean Master the products of three separate stages in the sculptor's development, with the smallest representing an early phase, the largest an intermediate phase, and the mid-sized works a late or mature phase. The name-piece should probably be assigned to a middle phase despite its great size (it is the largest known example of the Dokathismata variety) because of its rather unbalanced proportions and because it shares with the small figure a closely similar treatment of the rear on which, for example, the incisions marking the back of the arms are omitted.

One might well ask why the smaller, less refined works should be regarded generally as earlier products of an artist's career, especially since it was probably no easier, only less time-consuming, to carve a small figure. It is quite possible that the purchaser's requirements, which might have been controlled by economic considerations, helped determine the dimensions of a particular piece of sculpture; the wealthiest customers might have preferred larger figures, the less wealthy smaller ones. In this case, sculptors may not necessarily have carved small images exclusively during their formative years. However, it is likely that they first mastered their craft by making small, unassuming figures and only attempted larger, more ambitiously conceived ones later on.

One might compare the small, allegedly early works of the Goulandris Master and of another sculptor called the Steiner Master (figs. 60, 61, 75) with their larger, more mature figures (figs. 64–67, 76); the earlier ones appear coarse, heavy, and compact. Even though in each case the basic concept is the same, the smaller figure is not as well balanced or elegant, and is, in fact, plain by comparison. For the Goulandris Master, the smaller work lacks the highly controlled and subtle contours as well as the separation of the forearms which appear in the larger works; furthermore, not enough room is allotted for the delicately incised fingers so char-

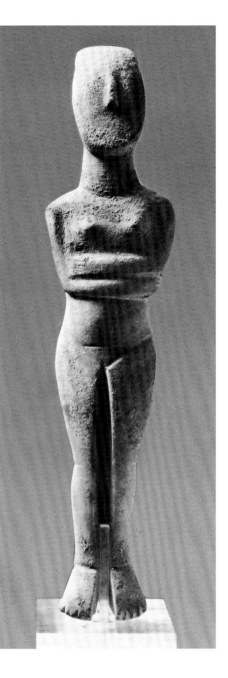

Figure 75. Female folded-arm figure. Late Spedos variety. A work of the Steiner Master. EC II.
A figure of rather modest size in comparison with the next one from the same hand (fig. 76), it is, despite obvious similarities of form and detail, also rather stocky and coarse and is therefore to be thought of as an early work of its sculptor. Tokyo, National Museum of Western Art. S. 1974-1. H. 34.5 cm.

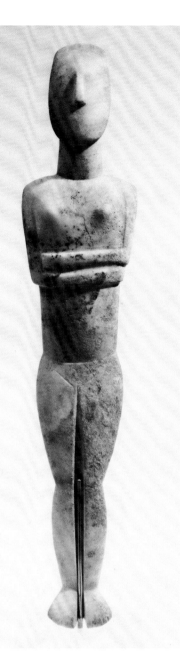

Figure 76. Female folded-arm figure. Late Spedos variety. Name-piece of the Steiner Master. EC II.
Unusually large, the figure is harmoniously conceived and masterfully executed. In an effort to make this work more slender, the sculptor elongated all parts for a very balanced effect. Note the graceful curvature of the outline contours, including that of the top of the head, which reveals the self-assurance of a master at the peak of his development. New York, Paul and Marianne Steiner Collection. H. 60.2 cm.

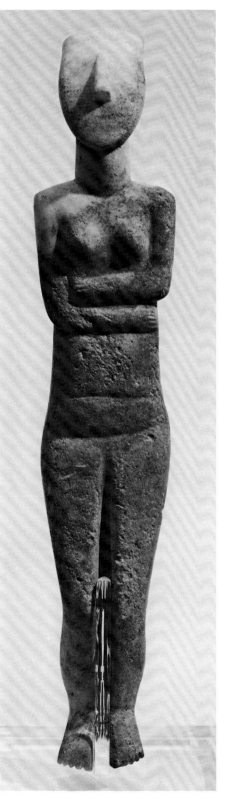

Figure 77. Female folded-arm figure. Early Spedos variety. EC II.
A carefully fashioned figure especially interesting for its surviving painted detail (pl. VIc, d), the piece is at present unique among Cycladic sculptures for its painted ears. A pattern of dots is also clearly visible on the face, and some of the grooves retain traces of paint as well. The treatment of the midsection with an extra horizontal incision is unparalleled. New York, Paul and Marianne Steiner Collection. H. 49.5 cm.

acteristic of his later work. For the Steiner Master, the smaller figure lacks the graceful curvature of the outline contours and the carefully elongated effect of the larger work. Such embellishments and refinements do much to alter and enhance a figure's appearance.

On the other hand, the rare virtuoso pieces—the harpers or the three-figure group—were surely the most difficult of all Cycladic sculptures to carve, partly because of their small size. They must have been made by sculptors who had polished their skills by making the usual folded-arm figures. These sculptors would have attempted the much more demanding figure types only after they had developed their techniques and honed their styles. Even then, in the absence of such modern aids as sketchbooks and plasticene or plaster models, their first attempts must have been less successful than their later ones. Something of the progress from piece to piece may be sensed in a pair of harpers said to have been found together and evidently designed as companion pieces

(figs. 23, 47). In general, figure *b* is the more carefully executed of the two; it is also considerably freer and more relaxed in attitude. It would appear, in this event, that *b* was carved after *a* and that it benefited from the experience gained by the sculptor during the making of *a*. Since both works reveal the hand of a sculptor proficient in the rendering of this difficult figure type, one must also assume that these are not the first examples of the type to have been carved by him.

Finally, one might consider the extraordinary harp player illustrated in plate IV*b* (and figs. 24–25 and on the cover). A sculpture of superior quality that goes well beyond mere technical virtuosity, it is remarkable for the harmony of its subtly curving forms and for the excellence of its workmanship and surface finish. It goes without saying that such a well-balanced work must have been planned with great diligence and precision. The most important side, as in all the harpers, is the right one; but the other three are also well conceived, and the sculpture may be viewed from any angle with almost equal effect. One can easily appreciate the strong influence of the dominant folded-arm type, especially in the treatment of the legs which are joined by a membrane of marble perforated between the calves. Although at present no other works by the same hand can be identified with confidence—the attribution to one sculptor of figures executed in different postures being exceedingly difficult—the piece illustrated in figure 77 is at least a possibility. However, in the absence of a number of folded-arm figures definitely attributable to the sculptor of this harper, one can only speculate about his artistic career, the apex of which this masterpiece must surely represent.

The Distribution of the Figures

Marble figures have been found on many, if not most, of the Cyclades, though only a few islands have yielded large numbers. In the first period, Paros appears to have been the main center of production, while in the classical phase this distinction evidently passed to Naxos, the largest, most fertile, and most populous of the islands. Curiously, the place that has yielded the greatest concentration of marble objects is Keros, a small and rather inhospitable island between Naxos and Amorgos.

Literally hundreds of vases and figures of the second phase of the Early Cycladic culture, mostly fragmentary, have been recovered on the southwest coast of Keros in what was usually thought to be a cemetery, although the suggestion has recently been made that it was a large open-air sanctuary (figs. 18, 53, 60, 68). The purpose of the site might be revealed through further exploration, but for now, it is at least clear that the island itself could not have supported a population either sufficiently large to have required the services of a great many sculptors at any one time or wealthy enough to account for the acquisition of so many objects from outside sources. For indeed, the quantity of these marbles rivals those of all the other islands in the archipelago.

One must wonder if Keros, with its small all-weather harbor, did not enjoy a special status either as a major trading station at the crossroads of Aegean shipping routes, or as a pan- (or, at least, southern) Cycladic sanctuary—a prehistoric Delos as it were. It is also possible that the island served as a burial ground for privileged inhabitants from other islands. It seems highly unlikely in any case, whatever the explanation, that the majority of the objects found on Keros were actually made there by local marble carvers.

Beyond the Cyclades

The carving of small-scale human figures in marble, limestone, or alabaster was widespread over the greater Mediterranean and Near East during the third millennium B.C. and even earlier. Particularly strong traditions flourished around the same time as the Cycladic in Anatolia (figs. 81, 82) and in Sardinia, with numerous surviving examples, while occasional pieces have been unearthed in Cyprus (figs. 78–80), Persia, and the Balkans, to name only a few places. With few exceptions, the female form is depicted, usually in a schematic or highly stylized manner.

There is no concrete evidence that the Cycladic sculptural tradition was directly influenced by or exerted a direct influence on the tradition of any of the contemporaneous nearby cultures except those of Early Minoan Crete and Early Helladic Greece, where it was clearly imitated. A few examples of Early Cycladic sculpture also found their way to the coast of Asia Minor but apparently went no farther east. The Early Bronze Age levels of the Cyclades are strikingly free of nonperishable items from other lands: a single stamp seal from North Syria (which may, however, only be based on North Syrian models) and one or two schematic Anatolian-type idols allegedly found in the Cyclades constitute the sum total of possible artistic imports to the islands at this time.

It is highly unlikely, moreover, that the sculptors themselves traveled beyond their own cultural spheres, if indeed they even ventured much beyond their own or neighboring islands. Whatever the traffic in perishable goods and raw materials might have been in the Aegean during the third millennium B.C., artists of the period probably spent much or most of their time involved in subsistence farming and herding. Their relative isolation quite literally would have insulated them from outside influences and would have had the effect of strengthening and formalizing their own traditions. Inasmuch as sculptors throughout the region were engaged in seeking solutions to similar problems and in fulfilling similar cultural needs, it should come as no surprise that the results of their en-

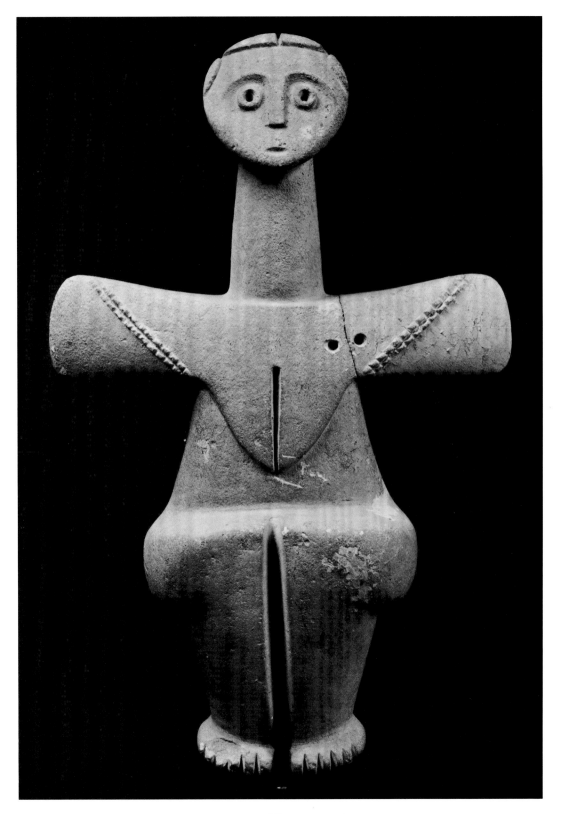

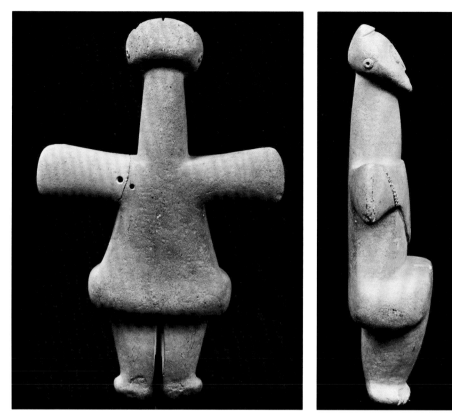

deavors occasionally appear similar.

Cycladic sculpture probably differed from contemporaneous sculpture of other lands less in meaning than in the tenacity with which the artists followed rigid standards of form and beauty. Within this precise design framework, Cycladic sculptors achieved superb technical mastery of the marble, and in the best examples of the classical phase their figures reflect a harmony of proportion and a balance of form and contour that is rarely matched elsewhere in prehistoric art. Adherence to such strong aesthetic principles by Cycladic sculptors makes their figures especially appealing as a group and also naturally encourages one to think ahead two millennia to the achievements of Archaic Greek sculptors whose basic ideals, formulaic approach, and rigorous methods of controlling the same fractious medium were not so very different after all, however fortuitously, from those of these earliest marble masters.

Figure 81. Female (?) figure. Kusura type. Anatolian Early Bronze Age.
A typical, albeit exceptionally fine, example of a schematic form produced in considerable numbers in southwestern Anatolia during the third millennium B.C. New York, Woodner Family Collection (ex Pomerance Collection). H. 24.2 cm.

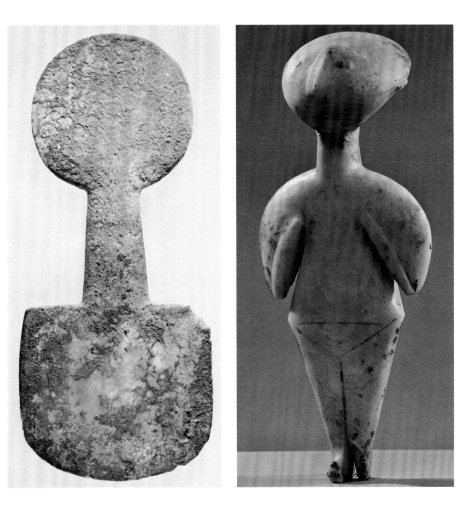

Figure 82. Female figure. Kilia type. Anatolian Chalcolithic or perhaps Early Bronze Age.
One of the finest and largest known examples of a type that first appears in very early levels at Aphrodisias and is often compared with Cycladic sculpture. The type is known from a number of stone examples as well as from one diminutive one in electrum. With their bulbous heads and flipperlike arms, they actually bear very little resemblance to Cycladic figures which they seem, in any case, to antedate. New York, The Metropolitan Museum of Art L66.11 (on loan from the Guennol Collection). H. 22.5 cm.

Major Collections of Early Cycladic Sculpture (Including Stone Vases)

Note: Smaller collections or individual pieces of some importance are to be found in many American museums. Among them: Indiana University Art Museum (Bloomington), Museum of Fine Arts (Boston), The Brooklyn Museum (Brooklyn), Fogg Art Museum (Cambridge), Cincinnati Art Museum (Cincinnati), Museum of Art and Archaeology, University of Missouri (Columbia), Des Moines Art Center (Des Moines), Kimbell Art Museum (Fort Worth), The J. Paul Getty Museum (Malibu), Yale Art Gallery (New Haven), Virginia Museum of Fine Arts (Richmond), and Seattle Art Museum (Seattle).

Selected Bibliography

Doumas, C. *The N. P. Goulandris Collection of Cycladic Art.* Athens, 1968.

———. *Cycladic Art: Ancient Sculpture and Pottery from the N. P. Goulandris Collection.* London, 1983. (Although a number of museums have published similar versions of this catalogue [e.g., the National Gallery of Art, Washington, D.C., 1979], this is the most inclusive and also benefits from an introduction by C. Renfrew.)

———. *Early Bronze Age Burial Habits in the Cyclades.* Studies in Mediterranean Archaeology 48 (1977).

Fitton, J. L., ed. *Cycladica: Studies in Memory of N. P. Goulandris.* Proceedings of the Seventh British Museum Classical Colloquium, June 1983. London, 1984.

———. "Perditus and Perdita: Two Drawings of Cycladic Figurines in the Greek and Roman Department of the British Museum." In *Cycladica*, pp. 76–87. *See* Fitton, 1984.

Getz-Preziosi, P. "An Early Cycladic Sculptor." *Antike Kunst* 18 (1975) 47–50.

———. "Five Sculptors in the Goulandris Collection." In *Cycladica*, pp. 48–71. *See* Fitton, 1984.

———. "The 'Keros Hoard': Introduction to an Early Cycladic Enigma." In D. Metzler and B. Otto, eds., *Antidoron Jürgen Thimme*, pp. 26–44. Karlsruhe, 1982.

———. "The Male Figure in Early Cycladic Sculpture." *Metropolitan Museum Journal* 15 (1980) 5–33.

———. "Nine Fragments of Early Cycladic Sculpture in Southern California." *The J. Paul Getty Museum Journal* 12 (1984) 5–20 (a discussion of the pieces illustrated in fig. 53).

———. "Risk and Repair in Early Cycladic Sculpture." *Metropolitan Museum Journal* 16 (1981) 5–32.

———. *Sculptors of the Cyclades: Individual and Tradition in the Third Millennium B.C.* Forthcoming. Ann Arbor and Los Angeles, 1985.

———. *The Goulandris Master.* Forthcoming. Athens, 1985.

Getz-Preziosi, P., and Weinberg, S. S. "Evidence for Painted Details in Early Cycladic Sculpture." *Antike Kunst* 13 (1970) 4–12.

Havelock, C. M. "Cycladic Sculpture: A Prelude to Greek Art?" *Archaeology* (July/August 1981) 29–36.

Oustinoff, E. "The Manufacture of Cycladic Figurines: A Practical Approach." In *Cycladica*, pp. 38–47. *See* Fitton, 1984.

Papathanassopoulos, G. *Neolithic and Cycladic Civilization.* Athens, 1981.

Preziosi, P. G., and Weinberg, S. S. *See* Getz-Preziosi and Weinberg, 1970.

Renfrew, C. "The Development and Chronology of the Early Cycladic Figurines." *American Journal of Archaeology* 73 (1969) 1–32.

――――. *The Emergence of Civilisation: The Cyclades and the Aegean in the Third Millennium B.C.* London, 1972.

――――. "Speculations on the Use of Early Cycladic Sculpture." In *Cycladica*, pp. 24–30. *See* Fitton, 1984.

Thimme, J., gen. ed. *Art and Culture in the Third Millennium B.C.* Chicago, 1977.

Zervos, C. *L'Art des Cyclades du début à la fin de l'âge du bronze.* Paris, 1957.

Photo Credits

Curtis D. Bean 71, 72
British Museum 27, 35, 66, 67
Gad Borel-Boissonnas III
Geoffrey Clements 1d, vic, vid, 76, 77
Prudence Cuming Associates 60, 61
Christopher Danes 14, 68
Pierre-Alain Ferrazzini va
Seth Joel ivb, 25
Werner Mohrbach 24, 30, 31, 32, 58, 59
Otto Nelson 8, 23, 41
Elizabeth Oustinoff 43
Ken Strothman and Harvey Osterhoudt 64, 65
Sarah Wells 1b, 1c, vb, 20, 37, 49, 56, 57, 81
Dietrich Widmer 62, 63
Roger Asselberghs 4, 34

Reproductions are by permission of the owners of the original works, who supplied the color transparencies and black-and-white photographs unless otherwise specified. Photography of Getty Museum works of art by Donald Hull and Penelope Potter.

Colophon

Editor Sandra Knudsen Morgan
Designer David Arthur Hadlock, Los Angeles, California
Illustrator Martha Breen Bredemeyer
Copy Editors Susan Gallick, Carol Leyba
Photograph Editor Elizabeth Chapin Burke
Production Coordinator Karen Schmidt
Typography by Mondo Typo, Santa Monica, California
Printed by Alan Lithograph Inc., Los Angeles, California
Printed in an edition of 2,500 copies on Cameo Book Dull White, 80 lb.